BROOKLYN'S
BARREN ISLAND

A Forgotten History

Miriam Sicherman

MIRIAM SICHERMAN

THE
History
PRESS

Published by The History Press
Charleston, SC
www.historypress.com

Front cover, top: Courtesy of the Queens Borough Public Library, Archives, Eugene L. Armbruster Photographs; *bottom*: Courtesy of the Queens Borough Public Library, Archives, Eugene L. Armbruster Photographs.
Back cover, top: From *Scientific American*, August 14, 1897; *bottom*: Brian Merlis collection.

First published 2019

Manufactured in the United States

ISBN 9781467144315

Library of Congress Control Number: 2019948155

To the memory of Jane F. Shaw (1867–1939), educator and advocate, and to the past, present and future of Una Yoorim Sicherman Rose.

CONTENTS

ACKNOWLEDGEMENTS

Many people helped me gather and understand resources for this project. I would like to thank National Park ranger J. Lincoln Hallowell for providing the invaluable oral history of William Maier, as well as Mickey Maxwell Cohen and Gunda Narang for providing Josephine Smizaski's oral history. These resources made a huge difference in my ability to understand Barren Island from the point of view of Barren Islanders. Many others also responded to my questions and requests for resources, often going above and beyond in their efforts to help, including Wade Catts, Felice Ciccione, Mike Cinquino, Joseph Coen, Peggy Gavan, Jim Harmon, Dan Hendrick, Melanie Kiechle, Max Liboiron, Dana Linck, David Ment, Robin Nagle, Jozef Malinowski, Brian Merlis, Kevin Olsen, Amanda Patenaude, David Naguib Pellow, Skip Rohde, Elizabeth Royte, Lee A. Rosenzweig, Adam Schwartz, Lori Sitzabee, Howard Warren, Mary Willis, Ingrid Wuebber, Don Zablosky and Carol Zoref. They provided tremendously helpful, hard-to-find materials and advice.

Librarians and archivists at Brooklyn College, the Brooklyn Historical Society, the Brooklyn Public Library, the New York City Municipal Archives, the New York State Archives, Queens Public Library and the Roman Catholic Diocese of Brooklyn, as well as park rangers at Floyd Bennett Field, helped me find and understand many important resources as well.

Acknowledgements

My master's thesis advisor at Brooklyn College, Professor Michael Rawson, encouraged me to pursue this topic in spite of the challenges of finding information. I'm very grateful for the guidance and feedback he provided at each step of the research and writing process, and for his suggestion that I consider publication.

And to the many friends and family members who either enjoyed or endured my long tales of Barren Island, and even accompanied me on field trips to its vanished shores, thank you!

INTRODUCTION

One day in early March 1909, a New York City health inspector got on a boat at Canarsie Pier in Brooklyn and sailed to a place in that borough called Barren Island. In response to complaints from unspecified persons, he had come to find out who owned the more than five hundred illicit hogs that roamed freely amid the sand, marsh plants and garbage. (It was legal to keep hogs in a pen but not to let them roam.) All of the islanders disclaimed any knowledge of the hogs, and, presumably, they assumed that was the end of the matter.

But it was not. The twelve policemen of the health squad arrived by powerboat at 9:00 a.m. on Tuesday, March 16, 1909, a few days after the inspector's visit, revealing "not a hint" of their purpose. These "strapping" men were "armed to the teeth," the *New York Times* reported on the following day, with revolvers and two hundred rounds of ammunition apiece. Led by city sanitary superintendent Walter Bensel, they had a singular mission: Kill all the unpenned hogs on Barren Island. They would need all the strength they had to accomplish their assignment.[1]

Soon after they disembarked, their quarry began to appear all around them. "A shot rang out and a big white hog rolled over on his back....From that moment action was fast and furious." As the police dispersed across the island, they quickly discovered that their task would not be easy. First of all, the enormous creatures often had to be shot multiple times before they would fall dead. More dauntingly, seemingly the entire female population of the island suddenly emerged from their homes to protect the very same hogs

whom they'd claimed no knowledge of just days before. "The women, few of whom could speak English, were crying and pleading with the policemen not to shoot the hogs, while between their sobs they called what sound like 'Toi, Toi, Toi,' trying to get the rooters out of danger."

Immune to this pleading, the brawny health police proceeded with their grim assignment. They strode across the sandy, roadless island, shooting every hog they could find—hogs of every description. "Some were so old and lazy they would hardly get out of the way when kicked, while others, long legged, skinny and shaggy as Shetland ponies, could give a deer the race of his life in a Marathon." Although Barren Island's women presented the first line of defense, a number of men "came from the factories to rescue their hogs, several picking up in their arms porkers which could not have weighed less than 150 pounds each, carrying them bodily into the houses through the front doors." In addition to the lucky hogs whose owners herded them into their homes, some others escaped into the nearby marshes.

Several hours later, there were no more live hogs to be found outdoors. The policemen packed up their guns and headed back to the boat. Meanwhile, "those of the natives who were not engaged in dragging in the dead hogs preparatory to a great fry and roast last night were at their gates, shaking warning fingers and menacing fists at the policemen's broad backs."

This event, though it was a one-time incident, exemplifies many features of the unusual community on Barren Island in Jamaica Bay, where from the 1850s through 1936, several thousand immigrants and African Americans made a living from a variety of "nuisance industries." Though the health policemen's boat ride took only thirty minutes, it was quite common for the trip to take hours or even for it to be impossible, creating conditions where an isolated and neglected community developed its own quite effective survival strategies. The population over the years ranged from a couple of hundred to around eighteen hundred mostly disenfranchised residents, its small size allowing its municipal overseers to ignore it with few repercussions. The islanders responded creatively. They took advantage of their virtual invisibility in many ways, in this case by openly keeping hundreds of free-roaming hogs, contrary to the laws of the city. These hogs were a constructive response to two facts: garbage, which hogs ate, was everywhere on the island; and poor transportation made fresh meat hard to get. After the policemen came to shoot the hogs, the islanders made the best of that, too: if you can't save your hogs, you might as well have them for dinner. The hog situation was also indicative of ways in which islanders existed in a sort of living past. It had been nearly fifty years since free-roaming hogs had been eradicated

from more urban parts of the city,[2] yet here they were in 1909, "nosing along," "poking their snouts inquiringly into kitchen doors."[3] The island was stuck in the past in other, much less picturesque ways—such as the total lack of firefighting equipment, which forced islanders to form bucket brigades when fires broke out.[4] But the islanders quietly went on with their lives, coming up with countless ways to both benefit from, and compensate for, their geographical isolation and the neglect with which they were treated by the authorities. Ultimately, they organically created a unique community at once urban and rural, old fashioned and cutting edge.

This community was located between the mainland of Brooklyn and the Rockaway Peninsula in Queens, on land that is now part of Floyd Bennett Field, itself part of Gateway National Recreation Area. During the late nineteenth and early twentieth centuries, Barren Island was the home of a motley collection of so-called nuisance industries or offensive trades: garbage processing (in which household garbage was boiled or "reduced" to extract grease for industrial use, such as soap-making); fish oil processing; and, most of all, animal rendering, in which the thousands of horses that died in New York City every year—along with dogs, cats and the occasional bear or alligator—were transformed into fertilizer, sugar-refining ingredients and other essential products. (The rendering industry gave an adjacent body of water the name Dead Horse Bay.) The people of this odoriferous outpost, mostly unknown today, performed vital functions for the explosively growing city until the residential community was unceremoniously eradicated, gradually at first by the development of Floyd Bennett Field, New York City's first airport, and finally by the all-powerful hand of Robert Moses in the name of the construction of the Marine Parkway Bridge.

Though it was disgusting (at least to some) and isolated, and there were many hazards in the work, Barren Island represented a strikingly environmentally friendly way of dealing with the unending stream of garbage produced by the largest city in the United States. Scows arrived from Brooklyn and Manhattan daily, and rather than simply being dumped or burned, garbage and dead animals were turned into useful products. The much greater volume of garbage that New York City produces today is almost all shipped hundreds of miles away, on fossil fuel–burning trains and trucks, to be added to landfills in Upstate New York, Connecticut, Kentucky, New Jersey, Pennsylvania, Ohio, South Carolina and Virginia.[5]

Though many contemporary reports about Barren Island's industries focused solely on the machinery in the plants, the garbage on Barren Island, of course, didn't process itself. On the contrary, a gritty group of

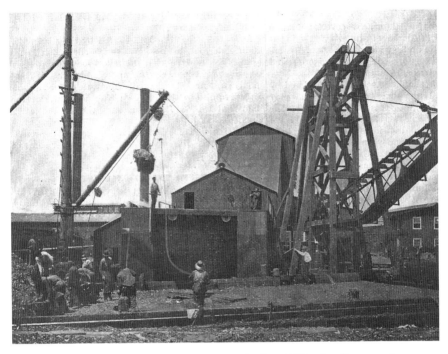

Hoisting garbage from the scows at the New York Sanitary Utilization Company factory on Barren Island. *From* Scientific American, *August 14, 1897.*

mostly uncomplaining male immigrant and African American workers performed labor-intensive processes in several factories. They had no choice but to live on the island, first in company dormitories and then, for most of the history of the island, with their families in small bungalows. Their wives cooked, cleaned, grew vegetable gardens, raised chickens and ducks and, of course, brought up the children. The island, connected to Brooklyn and the Rockaways only by ferry (and not even that in inclement weather), was home to an almost bucolic village with a small schoolhouse and post office, dusty paths and a few shops and taverns. Islanders spent their off hours clamming, crabbing, fishing and exploring; dancing at the dance hall; roller-skating in the school basement; going to the Catholic church with its Polish priest; swimming in Jamaica Bay; listening to the radio; getting water from the communal tap; and, occasionally, taking a trip off the island to the enormous cities that created the garbage that was the island's raison d'être. (Until 1896, Barren Island was a part of the Town of Flatlands; then it was briefly annexed to the City of Brooklyn. In 1898, Brooklyn joined New York.) All of this took place at the same time

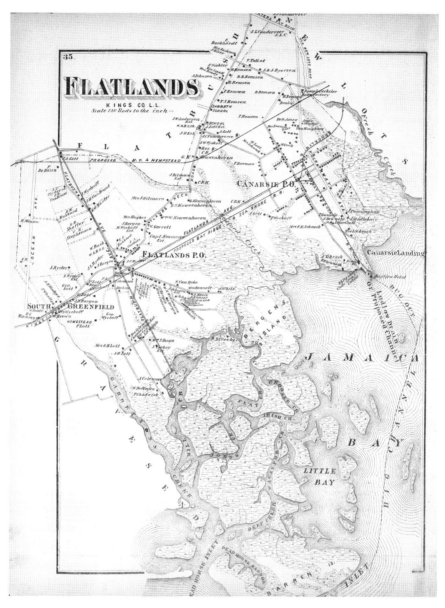

"Flatlands. Kings Co. L.I." *Lionel Pincus and Princess Firyal Map Division, New York Public Library. New York Public Library Digital Collections. https://digitalcollections.nypl.org/items/510d47e2-6349-a3d9-e040-e00a18064a99.*

that unprecedented millions of immigrants were arriving in New York, most of whom ended up in the record-breakingly dense tenement districts of the city proper.

In this isolated location, with no reliable transit and little attention from municipal agencies, Barren Islanders created a functional, even thriving, community that lasted in different forms for eight decades. They were proactive, flexible and sometimes opportunistic. The islanders made do for themselves in countless ways—from forming spontaneous bucket brigades that fought fires, to scavenging for driftwood to heat their own homes, to clamming and crabbing for dinner. And they took full advantage of the fickle, inconsistent attention of outsiders.

There is almost no visible trace of this community anymore. Even the boundaries of the island have changed almost beyond recognition, the result of both purposeful landfilling and unpredictable acts of weather and tide. The original Dead Horse Bay is gone, filled in. (There is now a Dead Horse Bay where there used to be Dead Horse Inlet, to the southwest of Floyd Bennett Field.) Flatbush Avenue was built out from Brooklyn in the 1920s and then connected to the Rockaways via the Marine Parkway Bridge in 1937. Most significantly, the island itself was connected by landfill to the Flatlands neighborhood of Brooklyn, ending its isolation and its unusual character.[6]

The airport at Floyd Bennett Field, built in the late 1920s, was a radically new function for this land. As it began operations, it overlapped with the last decade or so of the Barren Islanders' presence. Thus, the islanders—who only a short time before were cut off from the rest of civilization by ice for weeks at a time in winter and who saw their first automobile in 1918—were now the hosts to high-tech aircraft and globetrotting pilots. Children could spend the morning digging for clams in the mud and the afternoon watching the antics of barnstormers as they performed stunts in the sky. This juxtaposition of the timeless and the new was another unique aspect of life on Barren Island in its later days.

What was it like to live on Barren Island? To go to school at PS 120, come home to speak Polish or German or Italian with your family (your parents might have arrived at Barren directly from Ellis Island), or to hear the stories of your enslaved ancestors in the South, work in the horse factory, fish in the bay, get married at Sacred Heart Church by Father Malinowski, raise a family—and all the while to inhale the staggering stenches of the city's garbage? To know that you were performing one of the most essential functions of any urban place while also knowing that the city's residents, if

they thought of you at all, did so only to blame you for those putrid smells that occasionally blew toward their summer hotels and cottages in the Rockaways or Coney Island?

What was it like—and why does that matter? All told, a few thousand people lived in Barren Island over roughly eighty years, the peak being in 1910, when about eighteen hundred residents were counted by the U.S. Census.[7] Barren Islanders constitute a rounding error in the historical population of New York City. They were considered an amusing, smelly curiosity by the few urban counterparts who were even aware of their existence. The key to their importance lies in their work and their ability to create a functioning community in circumstances of neglect and even danger.

The work of the Barren Islanders was crucial to the functioning of New York City. Until the early 1900s, it was a city whose transportation of people and goods was horse-based. These animals lived an average of only a few years, and when they died, something had to be done with them. The obvious solution was to dump them in the surrounding ocean, but this was easier said than done. If the animals were dumped too close to shore, they'd wash up on the beaches, which nobody wanted, but to take them far enough out to sea was quite expensive and, depending on weather, could be dangerous or impossible. On the other hand, if they were sent to the "horse factory" on Barren Island, there would be jobs for workers and profits for factory owners, and the boats had to travel only a few miles. Nowadays, we would also say that this solution—the creation of fertilizer and other marketable products—was more environmentally friendly than dumping rotting carcasses into the ocean. At the time, that was not an issue anyone worried about. But waste of a different kind did matter: it was considered wasteful to discard anything that could potentially yield a financial profit.

Not only dead animals, but also household garbage was processed at Barren Island, at different factories—and, again, this prevented it from being dumped at sea. Through a boiling process known as reduction, grease could be extracted from the garbage and sold to industry all over the world. The remains of the garbage would be incinerated and dumped as ash; sometimes, it was used as landfill. Unfortunately, historical records do not reveal what proportion of Manhattan and Brooklyn's garbage was processed at Barren Island; some ocean dumping appears to have taken place at the same time. However, the predictable outcry about increased ocean dumping at times when Barren Island plants were shut down because of fires implies that a considerable portion was indeed processed there.[8]

There were two other industries at Barren Island at various points in time. Millions of menhaden, or mossbunker, fish—still harvested today for fish-oil capsules and other uses—were seasonally processed into oil and fertilizer on the island from the 1870s until the turn of the century.[9] And in its early years, Barren Island had a relatively small icehouse in which ice harvested each winter from rivers and lakes in the northeastern United States was stored before being sold locally during the summer and year-round farther south.[10] Again, these were essential yet often overlooked industries, and the workers were European immigrants as well as African Americans, some of whom may have been enslaved in the pre–Civil War South.

Nowadays, most of these functions still exist in transformed incarnations. According to the New York City Department of Sanitation, the city recycles only 17 percent of its waste and sends the rest to landfills out of the area.[11] Menhaden are still processed and turned into oil, though not in the New York area. And in spite of greater automation, people must still perform a lot of smelly, strenuous labor to make these processes happen. Though many contemporary Americans laud the increasing percentage of our waste that is recycled or repurposed, much less thought is given to the people who perform this work. Many recycling and garbage workers suffer from job-related illnesses and injuries as well as poor compensation.[12] Thus, the conditions under which such workers have labored at different times in history are still relevant today—we have not yet developed a safe and adequately compensated way of processing our garbage, from the point of view of these workers—setting aside the question of what should be done with the garbage in the first place.

Barren Island is also important because of the community created by these workers and their families, and that will be the focus of this study. While the millions of immigrants in Manhattan at this time also struggled and suffered, they were acknowledged and sometimes helped by the better-off in their community. Progressive-era reformers paid attention and created institutions and laws to address these issues. Settlement houses like Henry Street and University Settlement advocated for immigrants and helped them to assimilate and their children to succeed. Jacob Riis published his revolutionary photos of living conditions for Lower East Side immigrants in newspapers and in his book *How the Other Half Lives*, motivating upper-class New Yorkers to come to the aid of these newcomers. But when it came to Barren Island, Riis was once asked, while testifying for an investigation about the island's smells, if he had ever been there. His reply: "No, I have not; Thank God; I do not want to go there."[13] The Barren Island community

received only very limited assistance from outside its perimeter. Though this assistance was at times transformative—for example, the efforts of Jane Shaw, teacher and principal from 1918 to 1936, to get basic services like running water—it was the islanders themselves who bore the greatest burden of creating a community from scratch. In a way, the Barren Islanders were more similar to the pioneers heading west at the same time in American history than they were to their own demographically identical peers just a few miles away in Manhattan or Brooklyn.

How did they create this community? Barren Islanders wrought their community out of virtually nothing, scavenged their environment to create a livable existence, worked hard at difficult, backbreaking jobs and accepted it and moved on when the island's industrial life came to an end. They were impressively flexible in their adaptation to their new home, which in most cases must have been extraordinarily different from where they came from. They developed routines and customs, some inherited from their homelands and some invented in their new maritime environment. Islanders went along for the most part with the rules and requirements of their bosses, teachers and other authorities. However, they inferred that they could also ignore certain rules—for example, they sold liquor on Sundays, gathered shellfish against the rules and allowed their hogs to roam free—and mostly fly under the radar. They were independent in providing for their needs and adept at taking advantage of the occasional interest of powerful outsiders in getting their needs met. They took advantage of the few municipal services offered to them and occasionally demanded more, as when they petitioned for their own school and police station. And they embraced major changes—the development of the Flatbush Avenue extension and the airfield. To show the different ways in which Barren Islanders created a community in their peculiar circumstances, this book will survey different aspects of daily life, from work to school to firefighting and beyond, and will also examine the gradual end of this community.

Barren Island has previously been written about mostly in reports commissioned by the National Park Service (NPS), which has administered Floyd Bennett Field and its surroundings as part of Gateway National Recreation Area since 1972. One important source is Frederick R. Black's *Jamaica Bay: A History*.[14] Black used many primary sources, including the Town Records of Flatlands, U.S. Census records and newspaper articles, to create a summary of the industrial and residential history of Barren Island. Other NPS-commissioned reports were created by archaeological firms and by the National Park Service itself.[15] Each of these reports detailed archaeological

findings, mostly related to the Floyd Bennett Field era and mostly relying on Black for information about Barren Island. (Very few archaeological remains from the island's industrial era have been excavated.)

There are few scholarly papers relating to Barren Island. Kevin Olsen's article "What Will You Do with the Garbage? New York City's Progressive Era Sanitary Reforms and Their Impact on the Waste Management Infrastructure in Jamaica Bay" provides an analysis of the garbage reduction, animal rendering and fertilizer production industries on Barren Island. Olsen briefly summarizes the community life of the island and acknowledges that it is difficult to find firsthand accounts of islanders' experiences. His focus is on waste management as public policy and the evolving technology of waste disposal.[16]

While these reports and papers provide important information about the archaeological and industrial history of Barren Island, they are focused on land use, waste disposal and aviation technology, and thus generally discuss the community that grew there only in passing. Those more thorough discussions that do exist (primarily Black's report) provide an important foundation of factual information without accompanying detail or analysis of this information. Black himself points this out, stating that "encouragement should be given for historians and PhD candidates in American history to study the communities in the vicinity of the bay."[17] The processing of garbage and recycling will be a major issue for municipalities for the foreseeable future, and learning about the experiences of past communities of garbage workers can help planners for the future. The present study is intended to fill in this gap in Barren Island research.

In order to do that, it is important to locate resources that give the firsthand accounts that Olsen remarked were difficult to find. Not available to previous researchers was the oral history given by William Maier in a lengthy interview with National Park Service ranger John Lincoln Hallowell in 2012. At the age of ninety-four, Maier recalled with vivid detail many aspects of life on the island from 1917 to 1935. An additional oral history from Josephine Smizaski, who lived on the island from 1908 to 1918 and was interviewed (also at the age of ninety-four) by her niece Phyllis Smizaski, is much shorter but does provide an islander's point of view as well. A *New York Times* article from 2000, for which the reporter, Kirk Johnson, interviewed former islanders Edward Kishkill and Mary Gilligan, also helps create an understanding of what it was like to live on Barren Island.[18] The New York State Board of Health periodically investigated the many smell complaints about Barren Island and included testimony from islanders. New York City

Board of Education archives and Roman Catholic Church records show slices of daily life as well. These sources help to corroborate and elaborate on details found in sources like newspaper and magazine articles at the time, giving islanders their own voice.

A mostly self-sufficient community in an isolated location, devoted to garbage processing and other industries, appears to be unique. Though these "nuisance industries" have often been located outside the main parts of cities (especially as cities grow), they are rarely, if ever, so cut off from the urban area that they service. For example, many similar industries existed at the same time at Newtown Creek on the border of Brooklyn and Queens; however, workers at these factories could live anywhere in commuting distance and did not create a separate community of their own. As a result of Barren Island's unusual combination of qualities, it is difficult to find comparable studies.

This combination of qualities also means that a focus on Barren Island can add significantly to existing analyses of American perceptions of garbage workers. Because the workers on Barren Island lived there and so were in a sense "at work" all the time, they existed as garbage workers in all aspects of their lives, not just during their hours on the job. Their wives and children, too, inhabited the persona of garbage workers. Thus, the island offers a more intense, concentrated look at both outsiders' views of, and the lived experience of, these workers. Several scholars have concerned themselves with Americans' views of garbage workers. For example, Carl Zimring, in his study of scrap businesses, notes that "the dirty connotations of the waste trades extend beyond issues of sanitation to include notions of morality and xenophobia."[19] As described in chapter 2, outsiders' judgements of Barren Islanders often made reference to their foreignness and low morals. Robin Nagle, in her study of sanitation workers who collect garbage and recycling in New York City nowadays, notes that these workers are very often *willfully* unseen by the public."[20] She terms this condition "Invisibility Syndrome" and points out the irony of the fact that it afflicts workers whose tasks are absolutely essential to the basic functioning of the city.[21] In the case of Barren Islanders, the physical distance from the city amplified the invisibility of the workers.

As Nagle notes, sanitation workers suddenly get noticed in a big way when they do not do their jobs. This can happen because of weather, since New York City sanitation workers stop collecting garbage in order to plow snow when necessary. "The piles are immense…after even a short time without collection."[22] Collection may also stop in the event of a strike, producing

disgust and, in the Barren Island era, urgent fears of disease among residents. Daniel Eli Burnstein describes a 1907 strike in which "many New Yorkers began to panic" as the garbage accumulated.[23] Depending on prevailing political winds, such concerns can lead to either support for workers, as in 1907—on the argument that the government should satisfy them so that they could quickly go back to work and take away the garbage—or anger, as in 1911, when the workers were seen as threatening the health of residents with their unreasonable demands.[24] Either way, as soon as the snow is cleared or the strike is resolved, the public's attention moves elsewhere, and garbage workers again become invisible. In the case of Barren Island, this invisibility contributed to the municipal neglect of the residents. No one really wanted to pay attention to Barren Islanders unless they were somehow causing trouble for others, generally through the smells that were inevitably produced by their work. And even in those instances, the attention paid was not to the lives of the workers themselves but to the effect that the smells had on neighboring outsiders.

Hence, a closer look at the community created by the residents of Barren Island has the potential to teach us a lot about the experiences of essential workers from their own point of view, not just as cogs in an industrial or economic machine. By examining the evidence of their daily lives, we can learn about the self-development of a community of people who were ignored and reviled while performing a vital service for their city. In the current moment, as nations and regions around the world face the challenge of dealing with ever-mounting piles of waste produced by an ever-growing global population, a better historical understanding of sanitation workers' lives is not just a quirky curiosity but is also useful knowledge that can help plan future improvements to waste management—which, however automated, will always ultimately rely on human workers.

Finally, this study of Barren Island adds to our understanding of the development of coastal communities on the periphery of New York City. While New York is best known for its past position as a manufacturing center and its present as a financial hub, it also includes many neighborhoods in the outer boroughs whose residents, to this day, include a large proportion of the municipal workers who make the city run. Without these communities, the flashier aspects of New York could not function.

Barren Island was barely inhabited before the factories came, as described in chapter 1. Its highly changeable boundaries made it an unstable home from an environmental point of view, and its unpredictable but frequent inaccessibility required residents to fend for themselves. The population that

grew around the factories was a diverse one, composed of new immigrants and African Americans who had to find a way to get along in the absence of any organization that would have structured their interactions, apart from the factories themselves.

The work that these residents did was a determining factor in the views of outsiders, described in chapter 2. Municipal authorities, newspaper reporters and residents of nearby communities tended to view the islanders as pitiful and disgusting. This created the conditions in which Barren Island was often left to its own devices in most aspects of everyday life, again forcing the residents to come up with their own way of life and survival strategies. So successful were these strategies that residents fiercely defended their community in contexts from New York State Board of Health hearings to newspaper interviews. They themselves did not seem to be ashamed or embarrassed by their work. Chapter 3 tells the story of the factories in which the men of the island made their living, as well as the other types of work undertaken by residents—from unpaid domestic labor to small-scale entrepreneurship. The work inside the factories, as already mentioned, helped create the context for municipal neglect, while other types of work compensated for the lack of goods and services available on the island.

Needless to say, islanders did more than work. Their forms of recreation were in large part determined by their location and isolation. As described in chapter 4, unlike New Yorkers in more urban parts of the city, Barren Islanders had the daily opportunity to swim, fish and otherwise enjoy their natural setting. Once the airport came, they also had unusual recreational options—such as going up for a short flight or asking a pilot to release a homemade mini-parachute. Contemporary reports and later recollections make it clear that islanders took every advantage of the recreational possibilities of their home. On the other hand, the ability to practice their religious traditions was determined largely by the charity of outsiders who had the financial means to build churches and provide clergymen.

Islanders were also dependent on outsiders for certain services that they could not adequately provide themselves. Chapter 5 focuses on two of these services: firefighting and the provision of running water. Neither of these were ever attended to properly by the municipal authorities. With plenty of water but no water pressure, little equipment and no organized firefighting force, Barren Islanders had to fend for themselves during the not infrequent and often terrifying fires. They collected rainwater and dug wells when the city failed to install water pipes. Occasionally, they were able to attract a bit

of equipment for these purposes, but for the most part, islanders took care of their own needs as best they could.

Chapters 6 and 7 go into greater detail on two other types of municipal functions: law and order, and education. In both of these cases, Barren Islanders at times demanded attention from the city, but also in both cases, the city's attention was sporadic at best. When it came to law enforcement, the islanders to a great extent policed themselves, and the island was often described by its residents as peaceful and law-abiding, though there was a steady stream of alcohol-fueled fights in the pre-Prohibition era. There was a public school on the island from quite early on. In its first few decades, the school was very poorly resourced in terms of both the building and the teachers. Islanders did not apparently take steps to demand better schooling, but when the principal (and sole teacher) literally went mad, the city was forced to provide improved educational services. The islanders took full advantage of these improvements and of the subsequent arrival of a savvy, politically connected principal, who was able to build in ever more educational opportunities, including the chance to complete the eighth grade and qualify for high school.

This change coincided with the island's new connection to the mainland of Brooklyn in the form of the Flatbush Avenue extension—meaning the children could continue to high school not only in theory, but also in fact, because the island was no longer truly an island. Soon after that, the Barren Island Airport and then Floyd Bennett Field were built. Chapter 8 shows how the islanders quickly adjusted to their new, more connected status. Some got jobs in Brooklyn, many became aviation enthusiasts and others moved off the island as the factories began to close. As they had done throughout the history of Barren Island, the residents adapted and made the best of their circumstances—even as the island ceased to exist.

Although this story has, in some ways, a sad ending—the forced scattering of a functional, productive and by most accounts happy community—it is not a sad story. From the Barren Island experience, we can learn how a diverse group of people, thrown together in an isolated place only because they obtained jobs there, can create a small society that provides for itself and also adeptly summons resources from the larger municipality when possible. Though the islanders were neglected in many ways, and sometimes suffered as a result, in most important aspects of life they were able to thrive while, simultaneously, performing the essential task of processing the garbage of the nation's largest city.

1

EARLY HISTORY, LANDSCAPE AND POPULATION

The big thing on Barren Island was the tides.
Being on an island, the tides were the thing.
—*William Maier, former Barren Island resident, interviewed in 2012*

It was all white sand.... We had these dunes around, and wild roses would grow
around, and of course the water, the tide would come in.... That sand was pretty
hot in the summer, I'll tell you that much! No trees.
—*Josephine Smizaski, former Barren Island resident, interviewed in 2002*

The men employed there are negroes, Italians, Poles and other low class foreigners.
—Brooklyn Daily Eagle, *August 13, 1899*

There was once a place in Brooklyn called Barren Island; it does not exist anymore. It lay in Jamaica Bay, east of Sheepshead Bay and south of Canarsie. A marshy, grassy, sandy land of wind and dunes, the island's shape and size transformed rapidly as it was buffeted by changing tides and currents. Archaeologists believe it was never heavily settled by the local Canarsie Indians, though they likely used it as a base for hunting, shellfish-gathering and fishing.[25] In their turn, European settlers did the same and also grazed cattle and horses in the meadows.[26] And as the nearby cities grew, Barren's combination of proximity and isolation made it a perfect spot for so-called nuisance industries—those smelly, disgusting, but essential activities that city dwellers prefer to keep out of sight. Until then, only a few families lived on the island.

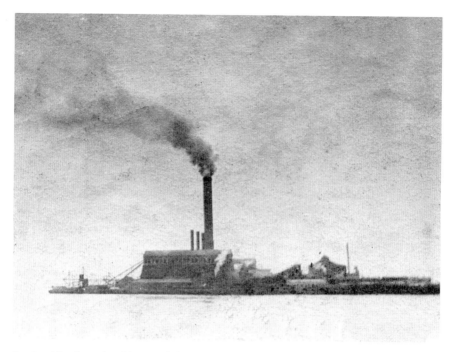

Smoke rising from the chimney of the Barren Island incinerator, circa 1904. *Lee A. Rosenzweig collection.*

Thus, when the first animal rendering and fish-oil processing plants were established in the 1850s, there was no local population to provide a labor force. African Americans from Virginia and newly arrived European immigrants were recruited to work in the plants. They had to live on the island, as there was no reliable way to commute there. Since they were not displacing anyone and had not come as a homogenous group, these new residents created a community essentially from scratch, combining their existing skills with newly acquired ones in order to satisfy their employers and meet their own everyday needs. Rather than carrying on the traditions of an established society, they made one up as they went along. The location and early history of the island helped to create the conditions that made this happen.

Known to the Canarsies as Equendito, which has been translated as "broken lands," the island progressed through a series of European names: Beeren Eylant (Dutch for "Bears Island"), Barn and finally Barren Island.[27] As the Canarsie name suggests, it certainly was frequently broken by tides, erosion and wind. In its earliest colonial days, according to historian Frederick

R. Black, "at low tide only shallow streams separated it from the mainland. Men and livestock could approach it on foot. Small craft had access to its northern shore, and larger vessels could come near its southern edge. These considerations perhaps explain why Barren Island was one of the first of the bay's islands to be utilized and inhabited by Europeans."[28]

These settlers quickly discovered that the island, like other marshy spots in Jamaica Bay, was highly changeable. According to the National Parks Service, which acquired jurisdiction over this area in 1972 when it became Gateway National Recreation Area, at times (as in 1839), Barren Island was connected to Pelican Beach and Plumb Beach to the west, while later storms drastically changed the landscape, once again separating Barren from those landforms by a newly formed inlet.[29] Supporting this story of transformation, in 1884, when only a few hundred people lived there, local historian Anson DuBois described Barren as a place of rapid change in recent memory: "Its length lay formerly north and south, but it now extends in greatest length east and west. The area of the island has very considerably decreased within the memory of persons now living."[30]

As time went on and the island's industries and population increased, Barren's instability became a serious problem. In November 1905, a large building used as a warehouse and dormitory "was sucked out of sight beneath the waters of Jamaica Bay....It took just thirteen minutes for the bay to swallow the building."[31] The next day, "another large slice of the island disappeared into the bay."[32] Islanders remembered similar past disasters, and everyone seemed to have a theory about why the island's boundaries were

"Double Page Plate No. 34." *Lionel Pincus and Princess Firyal Map Division, The New York Public Library. New York Public Library Digital Collections. https://digitalcollections.nypl.org/items/6e4b3210-0ab4-0132-ff3a-58d385a7b928.*

"Brooklyn, Vol. 3, Double Page Plate No. 39; Sub Plan from Plate 38; [Map bounded by Barren Island, Part of Ruffle Bar; Including Duck Point Marshes, Pumpkin Patch Meadows]." *Lionel Pincus and Princess Firyal Map Division, The New York Public Library. New York Public Library Digital Collections. https://digitalcollections.nypl.org/items/6c152750-a19e-6b6e-e040-e00a18061 1af.*

so unreliable: the meeting of multiple currents,[33] a "lake of quicksand… beneath the eastern point of the island,"[34] tides that were intensified by changes in the nearby Rockaway peninsula.[35] Though no one was quite sure exactly why pieces of the island tended to fall off, what everyone agreed on was the likelihood that it could happen again; "many of the inhabitants [were] alarmed lest the entire island sink into the sea."[36]

Some things stayed the same—like the sand. In the 1700s, "the Town of Flatlands leased Barren Island to William Moore, who mined beach sand from the area."[37] In 1830, the pirate Charles Gibbs buried treasure in the sand (only some of it was reportedly ever recovered), and the island was described as "wholly composed of white sand" by DuBois in his "History of the Town of Flatlands" in 1884.[38] Even in 1929, after the island had been attached to Brooklyn proper by landfill and the extension of Flatbush Avenue, a wandering hunter managed to become completely disoriented and fall unconscious during a sandstorm.[39]

But changeability was far more prevalent than consistency. Trees and other forms of vegetation appear to have come and gone. In 1884, DuBois wrote, "Years ago the island was destitute of trees, producing only sedge, affording coarse pasture. Sixty years ago cedar trees sprung up [*sic*] over the island, furnishing a roosting-place for vast numbers of crows. Few trees now remain."[40] In 1908, the *Brooklyn Daily Eagle* reported that "there are a few trees in this land in Jamaica Bay, consisting of straggling willows in the parts near the docks and factories, with quite a grove of cedars in the northwest

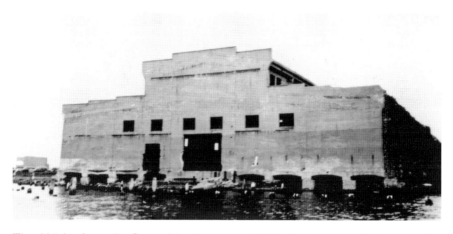

The old "glue factory" at Barren Island, summer of 1937. Factories were often located right on the water, and when the island's land shifted, they occasionally fell into Jamaica Bay. *Lee A. Rosenzweig collection.*

end."[41] In 1921, the New York City Parks Commissioner and Barren Island's school principal arranged for 150 public school students to take a field trip to Prospect Park. According to the *Eagle* (which was perhaps exaggerating), these children had "never seen a tree or flower and hardly a blade of grass."[42] Recalling a time not long afterward, William Maier, who lived on Barren Island from his birth in 1917 until 1935, stated in an interview that there was an area that during his childhood "we called the forest…there was a lot of brush and trees. And there was a couple of cedar trees. And I heard tell, years ago, when the island first existed, had cedar trees on the island. But these two cedar trees that were there, were dead."[43] The Cultural Landscape Report identifies these as Atlantic white-cedar and notes that they had been cleared from the island "during colonial times…[because they were] widely used for roof and siding shingles."[44]

The same report distinguishes several ecological zones on the island: marine intertidal sand beach, and a maritime dunes community that included both grassland and shrubland. The beach had "no vegetation but [was] abundant with marine life and shorebirds." Higher up on the dunes, there would have been "grasses and low shrubs, including beach grass, dusty miller, beach heather, bearberry, beach plum, poison ivy, and possibly stunted pitch pines or post oaks. Within the shrubland, species may have included many of those on the dunes, along with eastern red-cedar, Atlantic white-cedar, shining sumac, highbush blueberry, American holly, and shadbush. The grasslands [were] distinguishable from the shrubland

by dominance of grasses rather than shrubs."[45] Some of these species, as we have seen, were remembered by later residents. In addition to William Maier's recollection of cedar trees, he also had fond memories of beach plums: "Oh, I loved those beach plums....I was eating them before they got ripe. There was a lot of them. 'Let's go over and get beach plums!'"

In addition to land vegetation, Maier also remembered the rich animal life that residents took full advantage of to feed their families, or simply for recreation and appreciation of the natural world around them. "We had a place called Dead Horse Bay," he said. "And my sister and I, at low tide, we went in there, we would [search] for hard-shell clams. We'd walk in maybe an inch or two of mud, but after that was sand. With your bare feet, you can feel the clams. You can reach down and get the clams. My mother could make a real hearty clam [dish]. We could get an awful lot of hard shell clams." He also remembered distinctive ethnic traditions. "A lot of Italian people used to come down to the beach with their nets. They used to get these shiners [freshwater fish]....They used to pick mushrooms down there, too." And there were birds and more crustaceans: "We had a lot of wild geese on Barren Island, ducks, and cranes. We called them cranes, a lot of people call them egrets, herons....A lot of horseshoe crabs. A lot of fiddler crabs. Soft-shell clams. Hard-shell clams." Not all of these creatures were food for residents, but many were: Maier remembered that Deep Creek was "where we did what I call the snapper fishing," and of another stream he

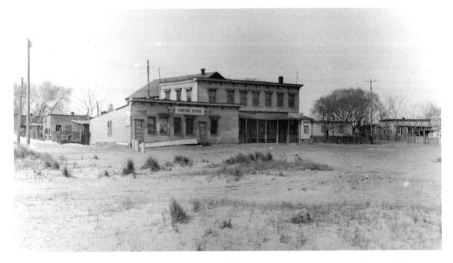

The Empire Hotel on Barren Island, north of Flatbush Avenue and west of Board Road, April 21, 1931. The ubiquitous sparse, grassy landscape is visible here. *Photo by Percy Loomis Sperr. Lee A. Rosenzweig collection.*

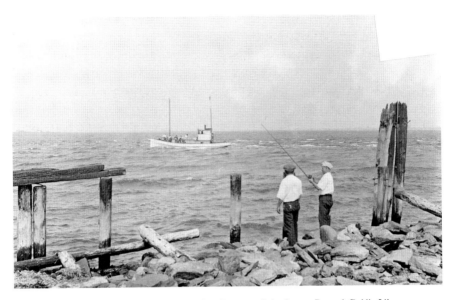

Men fishing on Barren Island, July 5, 1931. *Courtesy of the Queens Borough Public Library, Archives, Eugene L. Armbruster Photographs.*

recalled, "I remember when I was a boy, fishing there for those little killies, bring them home for the cats."

Along with the ocean, the shifting topography and the flora and fauna, another aspect of the natural environment that had important effects on Barren Island's history was the weather. Again and again after its population began to grow in the 1850s, newspapers reported on how ice and fog unpredictably, yet frequently, cut the island off from communication with other nearby communities. In December 1897, for instance, the boat that went to and from Canarsie was delayed for hours by fog several times and even got lost once, causing prisoners to miss court dates in Brooklyn.[46] In February 1899, the island was iced in for several weeks. "All navigation above Barren Island is stopped," the *Eagle* reported on February 2.[47] On February 10, the newspaper stated that the unfortunate "Frank Schowusky, aged 34, driver of a baker's wagon on Barren Island, was so badly frozen yesterday morning that Dr. Heeve, who was called, has doubts of his recovery."[48] By February 15, the ice was so thick that "one may walk…to Barren Island [from Canarsie or Rockaway] without difficulty."[49] Five years later, in February 1904, the *Eagle* reported that "all communication with Barren Island and Ruffle Bar [a smaller nearby island in Jamaica Bay] has been cut off for some time. The school teachers [who normally went home

on the weekends] have had to remain on the island."[50] Similar reports can be found over the years. Occasionally, someone would try to walk across the ice and freeze to death.[51]

But before Frank Schowusky and the public-school teachers ever set foot on Barren Island, it is very likely that the local Canarsie people had used its natural resources for centuries. Archaeological investigations suggest that it was not the site of a permanent settlement—perhaps because it was so unstable.[52] However, similar nearby sites have revealed "profuse remains of marine shellfish," as well as evidence of hunting for "elk, bear, deer, beaver, raccoon, and woodchuck" and birds. "Fish were captured by nets weighted with stones and by single-piece barbless bone hooks. Shellfishing equipment consisted of dug-out canoes and wooden rakes."[53]

The Indians were certainly considered by the early Dutch settlers to be the owners of this island. Anson DuBois, in Henry Stiles's *History of Brooklyn*, reproduces the text of the May 13, 1664 deed in which title was transferred from "Wawmatt Tappa and Kack-a-washke, the right and true proprietors of a certain island called by the Indians Equendito," to John Tilton and Samuel Spicer. In exchange the Indians received a variety of goods, including coats, a kettle, a gun, wampum, three shirts, six pounds of powder, "six barrs of lead and a quantity of Brandie wine."[54]

Probably due to its distance from larger settlements, the island appears not to have been used much for quite some time after 1664. In 1681, Tilton and Spicer transferred title to Elbert Elbertsonn, and the meadows provided "a scant pasture for young cattle and colts."[55] Around 1800, a man named Dooley or Dooly settled on Barren Island and opened an "ordinary" (a tavern or inn) for fishermen or others who found themselves in Jamaica Bay. According to DuBois, the ordinary was simply a "rude house," while Dooley himself was known as "The King of the Island" (a position for which he apparently had no competition); Dooley built another house for himself and his family.[56] A few other families also settled on the island, and salt hay and sand were harvested from the island in the nineteenth century.[57] Dooley's inn reportedly stayed in business until 1860, having been taken over in 1830 by John Johnson and later by someone named Cherry.[58]

It was during Johnson's tenure that the island experienced a brief moment of drama. According to a 1907 obituary for ninety-seven-year-old William Johnson (presumably another member of John's family):

In 1830 and the first part of the following year the police of New York were baffled by a gang of pirates who infested New York Harbor and the

adjacent waters. Many murders were committed by the pirates. Among these was the murder of Capt. Thornby and Mate William Rogers of the brig Vineyard. The pirates stripped the brig of everything valuable and then scuttled it.

With their plunder Gibbs and Wansley reached Barren Island in a rowboat. They gave William Johnson and his brother some Mexican silver they had taken from the brig to pay for food and lodging over night.

In the morning William Johnson discovered that his share of the silver had been stolen in the night. This aroused his suspicions, and, rowing over to the mainland, he notified the police. Gibbs and Wansley were arrested and convicted of the murder of Capt. Thornby and his mate. They were hanged on Bedlow's Island on April 23, 1831.

William lived a very long life after this incident and died in Canarsie, leaving "166 descendants, including 9 children, 60 grandchildren, 90 great-grandchildren, and 7 great-great-grandchildren."[59] According to a pamphlet about the Town of Flatlands, published by the *Brooklyn Eagle* in 1946, some of the Mexican money—supposedly buried on the island as Gibbs planned a getaway—was unearthed in 1842, and the rest has never been found.[60]

As the nineteenth century progressed, Barren Island remained mostly uninhabited. Meanwhile, in contrast, the populations of both Brooklyn and New York City (i.e., Manhattan) exploded, and the problem of waste disposal grew commensurately. It is not surprising that Barren Island—so close and yet so far—became an attractive option for entrepreneurs seeking to make a fortune, or at least a living, from the processing of household garbage, fish oil and dead animals. Since virtually no one lived at Barren Island, the laborers would have to be imported from elsewhere. The earliest factories turned to African Americans from the South and to the newest European immigrants.

These early factories on Barren Island, starting in the 1850s, were engaged in animal rendering and fish-oil processing, both considered "nuisance industries" because of the terrible smell. Prior to the 1880 census, island residents were not counted separately from others in the Town of Flatlands. An 1877 article in the *Eagle* reported, "at present the island has 281 inhabitants, ten of whom are women. About the first of November the fish factories shut down for the Winter and the population is largely reduced."[61]

For a report for Gateway National Recreation Area in 1981, Frederick R. Black summarized the available census reports. According to the 1880

census, the residents at that time were still mostly men and were living in company housing. Black noted that the vast majority of them were white laborers born in Germany or Ireland and black laborers born in Delaware and Virginia—along with a few whites born in New York. The labor force was clearly racially segmented, with black men providing unskilled labor in the fish factories and white men serving as their supervisors; only white men worked in the fertilizer factories.[62]

By 1880, along with the roughly two hundred residents living in company dormitories, "there were seventeen family-size units" with about one hundred additional residents.[63] These family households foreshadowed the coming changes in the island, in which the large company households would disappear. An 1890 *Sun* article stated that "between 500 and 600 persons live on this wet waste in a little world of their own. Barring half a dozen, they are all dependent on the island industry for their living." The article also noted that "the population is of a heterogeneous character. It comprises Dutch [probably meaning German], Poles, and negroes. The proportion of negroes is about one-half. They are employed mostly in the fish factories. They are natives of Virginia, and perfect specimens of the plantation darky. None of them is married."[64]

According to Black's analysis, by 1900, the company housing had disappeared and an average of about five residents lived in each household. Families paid rent to the city, which owned the land.[65] There were now black women and children as well as men, with the black population being about 20 percent of the total. The decline in the black proportion of the population from 50 percent in 1890 to 20 percent in 1900 was probably related to the decline in the fish factories that were their primary employers. Along with the Germans and Irish of the previous generation, there were also "sixty-eight Poles and forty-five Italians," reflecting the changes in immigration to the United States in general at this time. And there were hotels and boardinghouses, though no households as large as the ones in 1880.[66]

In 1899, the *New-York Tribune* reported that Barren Island had "a population of more than a thousand persons. Some of these were born there, and have never known another home, and there are those who have not been to the mainland for twenty-five years."[67] Clearly—the disparity in population estimates between this article and Black's study notwithstanding—the island had truly become a home for quite a few families, one in which they were raising children and establishing roots.

A 1904 *Eagle* article noted that the majority of the 1,400 islanders were "Polacks,"[68] and a 1908 article identified "the greater part of the

Barren Island, circa 1937. *Lee A. Rosenzweig collection.*

inhabitants" as "Russian Poles who do not speak English and have no desire to speak it."[69] The population of Barren Island peaked around 1910, when the island had about 1,800 residents.[70] By this time, the fish plants had closed because of a decline in the menhaden population, and in 1919, the last garbage plant closed. At the same time, with the rise of the automobile, the number of horses in New York City was decreasing, meaning there was less need for animal rendering. By 1930, the census showed a population of 374 people, of whom only three are listed as black, the rest white; the majority were now born in the United States, with some coming from Italy or Poland. After the eviction of islanders from city-owned property in 1936 and the closure of the last factory, a few hangers-on moved to private land on the island (no longer properly an island). The 1940 census listed 135 residents with jobs like fisherman, ironworker, laundress, woodworker and—most commonly—housewrecker.[71]

The ethnic and racial diversity in the Barren Island community over the years, living together on a tiny, isolated bit of land, leads to the question of how these different groups may have interacted, or not. As we have seen, the labor force tended to be segmented, at least by race, so there may have been little interaction at work. William Maier, who grew up on the island in the 1920s and '30s, was the son of German immigrants. He commented with regard to socializing outside of work: "I don't think our family went to the

Italian families or the Polish families. But I'm sure that some of the Polish families intermixed with [each other]." The *Brooklyn Daily Eagle* similarly observed that "the Polacks and negroes, who, for the most part, are employed in the garbage rendering works, have each a community of their own, while the Germans and others employed in the 'horse factories,' where more skill is required and the work is slightly less arduous, have erected their homes on the high, sandy hillocks nearer their places of employment,"[72] and reiterated a few years later that "the different races form colonies by themselves."[73] There are only a couple of reports of ethnic groups as such clashing with each other.[74] One gets a sense of a shared live-and-let-live attitude, with little unnecessary interaction between groups and little conflict. One place that the children, at least, must have interacted was the public school; however, no available sources report on the character of interethnic interactions there.

Barren Island's location was central to its roughly eight decades as a center of "nuisance industries." It was close enough to Brooklyn to reach most of the time yet far enough to avoid disturbing the neighbors—at least at first. Its distinctive environment, different from most other parts of Brooklyn and New York City, provided both hazards (ice, wind, fog and erosion) and opportunities (the convenience of many natural food sources from land and sea).

Barren Island was also far enough from Brooklyn proper that its workers were forced to become its inhabitants. Coming from a variety of locations, and with a variety of languages, religions and traditions, the Barren Islanders formed a mostly peaceful community that learned to fend for itself. The circumstances of the island led to a situation in which that community would either sink or swim; for the most part, it swam. In the coming chapters, the islanders' ways of life will be described in more detail. But first, we will learn about the views of outsiders—powerful people who tried for many years to influence the course of life on the island and whose perspectives often contrasted sharply with those of the islanders themselves.

2

OUTSIDERS AND INSIDERS

It is nauseating; perfectly so...rotten, disgusting, swilly, unbearable to mankind. I am very glad to have the opportunity to inveigh against that nuisance.
—Jacob Riis, author of How the Other Half Lives, *describing the smell of Barren Island, in testimony to the New York State Board of Health in 1897*

Our Barren Island [had] *a bad name. But to me, it didn't make any difference. That was paradise, for me! That was paradise.*
—William Maier, former Barren Island resident, interviewed in 2012

The first rendering factories were established on Barren Island in the 1850s and took a hiatus in the 1860s.[75] But in the 1870s, they returned, and a variety of "offensive trade" factories operated until the early 1930s, igniting a formidable array of curious observations, angry grievances, fears of disease and condescending remarks. Records of outsiders' opinions of Barren Island and its residents include hundreds of newspaper articles as well as many pages of testimony before the New York State Board of Health, to whom it fell to respond to the many nuisance complaints. It is not hard to find evidence that many outsiders saw Barren Island and Barren Islanders as disgusting, smelly, simple and foreign.

It is much more difficult to determine how Barren Islanders saw themselves and their home. Many of them did not speak English fluently, and newspaper reporters tended to pass them by. Charity-minded outsiders appear to have drawn their own conclusions about what islanders thought and needed without consulting the islanders themselves. What records the

islanders may have kept for their own purposes are not stored in public archives. However, in two oral histories and in islanders' own testimony before the state board of health, an image emerges of a place quite different than that described by outsiders: a pleasant and healthful environment, a place where people minded their own business and ran their own lives, with little help or interference from off the island.

The issue of smell provides the most vivid contrast between the perspectives of outsiders and islanders. Visitors and residents of nearby communities, such as Canarsie, Coney Island and the Rockaways, repeatedly described the factory smells in nearly apocalyptic terms. Residents and owners of summer resorts in those locations (often called "country towns" in the nineteenth century) stated that the stench was "sickening and overpowering,"[76] "intolerable,"[77] "so thick as to be pestilential."[78] Especially in the first half of the island's industrial history, the lingering belief that disease could be caused by bad odors induced fear in outsiders. This concern was expressed only as it might affect the health of neighboring communities—never that of the islanders. The residents themselves consistently stated that they didn't notice offensive smells, and their health was generally good—surprisingly so, from the point of view of outside observers.

Experiences of bad smells caused most outsiders who even knew about the island to want to shut it down or, failing that, avoid it. This reaction is part of the cause of Barren Islanders' freedom from outside interference (or help) when it came to their daily lives—though there were a few outsiders who genuinely got to know, and to love, the island. The islanders were generally able to continue their own preexisting habits, which were often seen by visitors as peculiar and quite foreign (and hence inferior to typical American habits). Sporadically, outsiders would attempt to impose their values and standards on the islanders; it is impossible to know how the islanders felt about this. But for the most part, disgusted and baffled outsiders were only too happy to leave the islanders alone.

Throughout Barren Island's industrial history, there were variations in how outsiders perceived the smells that emanated from the garbage, rendering and fish-oil factories. A few didn't mind. For state board of health investigations, attorneys for the factories were able to find residents of neighboring towns who found Barren Island smells nonexistent and inoffensive—or at any rate, even if offensive, not a threat to health. For example, testifying before the board of health on behalf of the fish factory, residents and businessmen from Jamaica, Woodhaven and other towns, as well as people who had visited Barren Island to inspect the factories, stated that there was "no disagreeable smell," "no

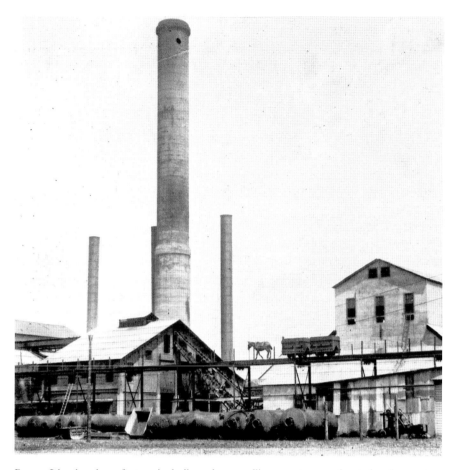

Barren Island garbage factory, including a horse pulling a cart on an elevated walkway, circa 1900. The smokestack was often cited as the source of offensive odors. *NPS/Gateway NRA Museum Collection, catalogue number 18859.*

decided odor" and the like. Rudolph G. Solomon, who described his business as "tanning alligator skins, kangaroo skins, porpoise skins, horse hides," visited the rendering factory and spoke at length to express his "astonishment" that there were no offensive odors and that, upon leaving the factory, the sole of his patent leather shoe "was just as clean as it was when I entered."[79]

Some commentators opined that Barren Island was a healthy environment—perhaps even healthier than other parts of the city. Charles H. Sproenig, testifying before the state board of health, said in 1897 that he spent four weeks on Barren Island after his doctor told him to go to the seashore because he was "affected a little with consumption." Sproenig

stated that, as a result, he had been cured and now felt "good." Dr. Joseph S. Boynton, who lived in Canarsie and practiced both there and on Barren Island, was forthright about the existence of odors and about his opinion that they had no effect on health. And Dr. William S. Tromer, a former health officer for the Town of Flatlands, went so far as to describe the health of islanders as "decidedly better" than that of residents of nearby Canarsie.[80]

However, for most of Barren Island's history, the voices arguing that the smells were inoffensive were small in number and low in volume compared to those complaining about the stench. Nuisance complaints about Barren Island began to pile up in the late 1870s. Many of these were directed toward the New York State Board of Health and to the state legislature. In response, a number of laws were passed to attempt to force Barren Island factory owners to make their processes less smelly or close down. New Yorkers from off the island hailed the passage of each bill, as in 1899, when the *World* newspaper reported that "the people who live in Brooklyn, Coney Island, Gravesend, Sheepshead Bay, Canarsie, Bergen Beach, Arverne, Edgemere and the Rockaways can now rejoice that their nostrils will no longer be assailed by the powerful, putrid, pungent, penetrating, poisonous, prodigious odors that have arisen from Barren Island."[81] Although the list of communities affected by this bill is quite lengthy, it omits any mention of Barren Island itself. ("Brooklyn," in this context, referred to the Town of Brooklyn, not the whole borough.) One is left to wonder whether the islanders would be rejoicing or not, but either way, they were not worth mentioning from the point of view of the *World*'s reporter.

This stance was typical of reports about the Barren Island odors and was consistent with smell-related concerns elsewhere in nineteenth-century America. As historian Melanie A. Kiechle writes of this time, "seemingly no one cared what air industrial laborers breathed."[82] "Popular ideas about the lower classes, particularly immigrants and racial others [precisely the population of Barren Island], held that these coarser individuals did not notice or care about filth."[83] Indeed, newspaper articles about the stenches usually did not make any mention whatsoever of the islanders. A representative example comes from the *Brooklyn Daily Eagle* of February 1, 1881, which described factories "in which the rendering of offal…causes a terrible odor which is a veritable plague to the residents of the country towns, especially in the Summer time, when their life is made unendurable."[84] Similarly, on August 18, 1888, the *Evening World* reported about "Barren Island, with its bone-boiling nuisances, the odors from which have so long assailed the noses of those who seek fresh air and recreation at the various beaches near by."[85]

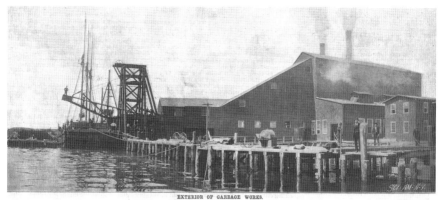

The exterior of the New York Sanitary Utilization Company factory on Barren Island, including, on the left, the apparatus for lifting garbage from scows. *From* Scientific American, *August 14, 1897.*

The awful smells were often seen not only as destructive of neighbors' enjoyment of their daily lives, but also as health threats. Both ordinary New Yorkers and medical professionals raised this concern. Testifying before the state board of health in an exhaustive investigation in 1897, Dr. Charles F. Roberts, an inspector for the board, stated authoritatively of the odors "that any person inhaling them would be more liable to contract any disease which they have been brought in contact with."[86] A letter writer to the editor of the *Brooklyn Daily Eagle* in the same year, contemplating a proposed increase in the amount of garbage to be processed at Barren Island, predicted that "the evil complained of will be twice as bad as it is at present and an epidemic of disease will result."[87] Another doctor, identified as R. Boocock, wrote to the *Brooklyn Eagle* in 1898 to say that his community had been "poisoned" by the odor from Barren Island, which was "disease breeding."[88] As Kiechle notes, by the late nineteenth century, the germ theory of disease had overtaken the earlier miasma theory in much of the scientific establishment. (The miasma theory held that bad air could actually produce illness.) However, as these comments about Barren Island's stenches demonstrate, the miasma theory persisted among ordinary Americans and even some doctors for some time. Regardless of whether they focused on fears of disease or simply abhorrence of terrible smells, those quoted in newspaper articles or giving testimony in board of health investigations confined almost all of their remarks to the effects of the smells on residents of neighboring communities, not on the islanders.

At times, commentators, rather than ignoring the islanders, made subtle but significant distinctions between them and other, more worthy people. Walter M. Fairchild, who spent summers in Rockaway Park, testified before the New York State Board of Health in 1897, mentioning concerns about illness: "I know my wife was made sick, and our servant girl, whom we think a good deal of....She is a *civilized* kind of girl."[89] A letter writer to the editor of the *Eagle* in the same year complained that the "vile odors emitted from the garbage works… if continued will have the effect of driving many *desirable families* away to more favored sections."[90] And Dr. Samuel Kohn, health officer of Arverne, Long Island (on the Rockaway peninsula), was quoted in the *Sun* in the same year: "Words fail to adequately describe this nasty 'offaly' odor. It seems incomprehensible that such an abominable nuisance should be allowed to exist at the very portals of the magnificent harbor of New York, to the detriment of the health of *thousands of New Yorkers who have built handsome cottages by the seashore, at an expense of millions of dollars.*"[91] (The emphasis is added in all three quotes.) Clearly, many people felt that the health concerns and noses of civilized, desirable, wealthy people ought to carry more weight than those of their primitive, unwanted, impoverished counterparts.

Occasionally, incidents occurred in which the islanders were actively discriminated against because of the smells. In 1879, the *Eagle* reported on a lawsuit in which an islander, Thomas Murphy, sued the Broadway Railroad Company of the Eastern District after being thrown off a train because he allegedly smelled so bad. In fact, the railroad company had made a specific rule that Barren Islanders could not ride on its trains. Murphy's challenge was unsuccessful. The jury "rendered a verdict for the defendant. It was then decided that although the railway company is a common carrier, that constitutional obligation does not include the transportation of smells."[92] Although Brooklyn and New York City depended on Barren Islanders for the processing of garbage, the people who actually performed this task could be discriminated against for reasons that arose directly from the processing itself.

Apart from such overt discrimination, the islanders themselves did not seem to have any major concerns about the odors. In a ninety-minute interview in which he recalled countless details of his childhood on the island, former resident William Maier did not mention smells once; the same was true of Josephine Smizaski, another former islander interviewed in her old age. Both of these former residents were interviewed many decades after their time living on the island. However, islanders interviewed by newspaper reporters and health inspectors during the industrial era were also dismissive of the odors.

In 1890, during a board of health investigation, Barren Islander Catharine Conway, who had lived on the island for twenty-six years, stated that she had noticed offensive odors but that they had not "bothered [her] to any extent" and pointed out that such odors are "perfectly right for the business that is carried on there."[93] Her interrogator connected the odors to health, asking about the health of the students in the school (including Conway's own children); "first-class" was her reply. Margaret Spencer, another islander, gave similar testimony, acknowledging that there was some smell but arguing that it was inconsequential. "I have plenty of people come to visit winter and summer and stay a week at a time, and who never complained of the existence of a smell." Mary Henchel, a twenty-five-year resident with many family members living on the island as well, testified that she and all of her relatives were healthy and that, in fact, in her view, the island was healthier than Brooklyn. "I have had a sister there [on Barren Island], the doctors have sent her there; she comes there with children."[94]

Mary Weinberg, who had lived on the island for thirteen years, was asked many different questions about the smells' possible effect on health during the 1897 investigation. She testified that she had never been sick, nor had any of her seven children, and that, in fact, she had never heard of anyone being made sick by the factory odors. When Weinberg went on to testify that she had never detected any smell from the fish factory at all, her interrogator became openly skeptical and asked if she had ever had her "nose examined." Weinberg gamely replied, "I smelt enough when I came down this morning…in Fulton Street."[95]

Newspaper reporters often noted that islanders did not notice the smells that the reporters themselves found so overwhelming. An *Evening World* reporter met a workman who "was a fat, jolly fellow and laughed at the idea of there being any disagreeable odor. He never discovered any."[96] And a reporter for the *Brooklyn Eagle* wrote, "One remarkable feature of the inhabitants of Barren Island is that they have absolutely no sense of smell. There are 800 persons on the island and they are all good average specimens of health. They are never worried by bad odors and will tell you that they never smell anything."[97]

Though smell was the most prominent issue raised when outsiders discussed Barren Island and its inhabitants, they also made observations and judgments related to other aspects of island life. These comments typically included disgust at the physical state of the island's houses and natural environment, repulsion at the odd habits and traits of the people and,

sometimes, a more benevolent curiosity about the quaint islanders. All of these responses signaled a deep alienation by the observers from the strange island where the observers' own garbage was daily transformed into useful products, preventing it from polluting the ocean and beaches.

Feature articles describing reporters' visits to Barren Island appeared regularly in New York City newspapers over the years. Almost invariably, reporters took a stance of otherness toward the islanders; these were marginal people, occupying a peripheral place, separate both physically and socially from other New Yorkers. A *Sun* reporter in 1899 wrote in a typical comment, "The islanders, remote and isolated and engaged in unusual employments, subscribe to all manner of queer domestic conventions and are distinguished from the commonplace majority of residents within the boundaries of Greater New York by many peculiar traits."[98] Reporters often described the people and their circumstances using words like "primitive"[99] and "unfortunate."[100] One reporter's statement neatly summed up the attitude of many outside observers: "When the traveller sets foot on shore there and takes one comprehensive glance around he will realize that in all but location he is in a foreign land."[101] Visitors most often found nothing in common between themselves and their own communities and this baffling island just offshore—and this judgment was usually made with just "one… glance," with no need for further investigation.

Not only newspaper reporters, but also the occasional visitor from city agencies or charitable organizations, as well as officials from the justice system, viewed the islanders as pathetic others. In 1915, Judge Norman S. Dike of Kings County Court, when explaining the leniency of his sentencing of two Barren Island teenagers, described the island as "that place on the outskirts of this big city, shunned by man and apparently forgotten by God."[102] In the same year, the New York City Department of Health included Barren Island in a "domestic education" program, in which a nurse was sent to live on the island and set up a station providing medical services, housekeeping advice and assistance in creating children's clubs such as scouting troops. The overt purpose of this program was to "Americanize" the mostly immigrant families. An article about the program painted a dark picture of life on the island prior to the nurse's arrival. "In the interior of the houses dirt and filth are the rule and windows are nailed down. Hard-working men and women, finding no wholesome form of recreation, indulge in drink to while the idle hours away. The resulting drunken brawls and racial squabbles draw the attention of listening children and the vile language they hear is soon effectively used in their own innocent quarrels." According to the writer,

the island was a "depressing" place rife with "diseased bodies, dirty homes, neglected children, illiteracy and drunkenness." Mothers had no idea how to properly care for children. The writer also criticized the islanders for their habit of sending surplus wages to their families back in the home country; presumably, it would have been preferable for them to invest these wages in the United States and leave their relatives back home to their own devices. Fortunately (from the point of view of the writer), soon after the department of health nurse arrived, women began to take better care of their families, children stopped spending time on the refuse heaps, people drank less alcohol and the new programs produced "a new civic spirit…a higher standard of living and…in this large group of foreigners a genuine interest in the welfare of the country in which they live."[103] Apparently, these islanders were ignorant and primitive, but educable.

The New York City Department of Health report on this program described an unremittingly "gray, cheerless environment" prior to the implementation of its improvements. But many newspaper reporters, to their surprise, found that these "peculiar" people seemed quite happy and healthy. The children, in particular, seemed to thrive despite their circumstances. "They are healthy, strong-limbed youngsters notwithstanding their life in such a place. They laughed and sang and recited and trooped into the playground as happily as city children," according to a 1901 article in the *Brooklyn Daily Eagle*.[104] Also describing the children some years later, a reporter wrote, "Why those sprites of the refuse heaps are as cheerful and joyous as if they were wading through fields of wild flowers up in Westchester county and chasing butterflies and gathering early apples instead of scurrying up a hill of refuse." The same reporter noted that despite being "unkempt…dirty and ragged," they were also healthy. "How or why they were so healthy nobody knows."[105]

Not only the children but also the adults were sometimes seen in more positive terms—but almost always from a patronizing point of view, reminding readers that the islanders were primitive, simple people; people who didn't know any better than to complain of their circumstances, indeed people who "didn't even know that they lived in New York city."[106] A typical more positive-sounding comment about these humble islanders was published in the *Brooklyn Daily Eagle* in 1908: "The Polacks are the most interesting—perhaps they are even picturesque—on account of their mere simplicity of life and manners."[107] The 1915 *Sun* article uses similar language: "There is a delightful picturesqueness about their old shawls, the shoes far too large, when existent at all, and frankly lacking toe or upper; about the

big, enveloping shirts, the occasional scarecrow hat—a wealth of gypsylike color and a most attractive abandon."[108]

It is important to note that not all observers were truly outsiders. Most newspaper reporters appear to have made a single visit and formed all of their impressions that way. But over the course of time on the island, a number of people unconnected with the garbage industry came to know Barren Island and its residents quite well. Several teachers, principals and janitors at the public school, as well as policemen—some of whom were initially reluctant to come to the island—developed a more nuanced understanding and appreciation of this unusual place as they spent extended periods of time there.

On August 18, 1901, the *Brooklyn Daily Eagle* published a long article about Barren Island that was highly critical and judgmental of "the deadly dullness of the island," which could be relieved only by alcohol and criminal behavior—in fact, it alleged that islanders actually murdered their family members for the purpose of combating their terrible boredom. The reporter also stated that the local dance hall was the scene of much immoral entertainment, including the spectacle of "young white women frequently choos[ing] negro partners" in front of their children.[109] These accusations were too much for the principal of PS 120, the Barren Island School, Daniel T. Edwards. He responded with a letter to the editor published on August 25, arguing that the islanders were "hard working, thrifty people—people who are respectable and who like to be accounted so. They are remarkably honest and generous almost to a fault. Habitual idleness is almost an unknown quantity down here." Edwards went on to say that "within the memory of the 'oldest inhabitant' no one—either factory employer or otherwise—has ever murdered wife or child on the island. Crime of any kind on the island is exceedingly rare." And he contradicted the notion that white female islanders might dance with black men. Though by today's standards, there would be no moral outrage if such dancing took place, by the mainstream standards of the time, Edwards was standing up for the notion that Barren Islanders were just as moral as anyone else.[110]

Another person who got to know Barren Island well was Policeman William Evans, who moved there in 1911 and married a local woman. In 1912, a rumor spread—and was printed as fact in several newspapers—that Mrs. Evans had had to fight off an angry mob of hundreds of people who came to try to free a prisoner who was temporarily being held in the Evans home.[111] These reports tended to confirm the image of islanders as uncivilized, prone to criminality and unassimilated to American norms of

law and order. Policeman Evans spoke to an *Eagle* reporter on November 3 to correct the record. (The *Eagle* had printed one of the erroneous articles on October 23.) Evans stated that not hundreds of "rough men," as previously reported, but rather "three or four women" had stopped by. "We don't have any more trouble down here than they have in New York. There are four saloons over here, and occasionally someone gets drunk, or starts a fight, but as a rule everything is quiet and peaceful. There are a lot of different nationalities, but the people keep to themselves." Mr. and Mrs. Evans both agreed that "it is very pleasant over here."[112]

Noah Decker was a resident who had been transplanted to the island against his will, assigned as the school custodian in 1919. According to his obituary in 1932, "he bitterly resented the assignment at the time." But the island became a happy home for him, and "he came to cherish the desolate spot with its hardy settlers above any spot on earth." Decker took on additional community responsibilities, forming a volunteer fire department and obtaining supplies and a firehouse. His neighbors accepted him: "Children looked to the gentle, elderly man as a guide and companion. The adults came to know him as a friend who would loan them money or place his car at their disposal when they needed it." Like Edwards and Evans, Decker adjusted to life on Barren Island and came to see his neighbors as members of a normal, well-functioning human community, not a desperate band of barbarians.[113]

The best-known transplant to make a home on Barren Island was PS 120 principal Jane F. Shaw. One of a family of sisters who distinguished themselves as New York educators, Shaw was assigned to Barren Island in 1918 and remained until the eviction in 1936.[114] In fact, she intervened directly with Robert Moses when he attempted to evict the islanders in April of that year, arguing successfully that children ought to be allowed to finish the school year. Shaw was by all accounts a legendary figure on Barren Island. Remembering her many years later, former resident William Maier said, "We had the public school, which was a whole center of Barren Island. It was a community center, it was a school by Miss Jane F. Shaw, a real tiger, a wonderful person, a real educator, and she put all us people in line. She helped the immigrants to become citizens, and she spoke well of everybody.…She obtained a lot of favors that I think we would have never obtained. It was a great thing to have somebody like that in our corner." Maier's comments encapsulate an important aspect of Shaw's time on the island: she stood up for the islanders and was able to influence city agencies to correct some of the neglect that had been the municipal stance for many years.

Shaw took these actions because she cared for the islanders. Though she had had no previous connection there, having taught in public schools in other parts of the city, she quickly came to see Barren Islanders as worthy people with as much potential to contribute to society as anyone else. She was interviewed by an *Eagle* reporter in 1930.

> *The island today, according to Miss Shaw, is the most moral spot in New York City. People never lock their doors, nor is there ever the slightest jeopardy to life or limb. "Barren Island is to these laborers exactly what Long Island is to wealthy people," she said. "They live here because nowhere else in the city can they raise their children under such economical and healthy conditions....When the city refused to build a road in from the causeway, they chipped in to the extent of $800 and built a board road, which every one uses. They get their water from artesian wells, which we've built ourselves. The ground is exceedingly fertile—thanks to the old garbage plant that used to be on the island. Every one raises his own vegetables. The school children have their own large and well-kept garden, from which they take home enough vegetables for lunch two or three times a week. Most of the residents have their own chickens, ducks and cows. Sunday is still the day for chicken dinners. It is a most self-contained community."*[115]

As demonstrated by this statement, Shaw not only worked hard to "obtain favors" (in William Maier's words), but also gave credit to the islanders themselves for their hard work in sustaining their families and building their community.

How did the islanders themselves, those who worked in the garbage plants and their family members, see their community? This question is harder to answer than the question of how outsiders saw them, because the islanders have left very little documentation. However, from what can be gleaned from oral histories, newspaper articles and the department of health records, islanders were by and large content with their lives. There is no indication that they saw it as a dreary, smelly, depressing place, as did so many outsiders. Rather, they took advantage of the opportunities that came with living in an almost rural place with room to roam and a decent salary—at the same time in history that many people with the same demographic characteristics (recent European immigrants and African Americans) were crammed into stifling tenements or sharecropping with no hope of saving a nest egg.

During a lengthy interview at age ninety-four, William Maier recalled many enjoyable aspects of life as a child on Barren Island. He described fishing,

The Coffee Pot, across the street from Floyd Bennett Field, July 5, 1932. A plank road, built by islanders, leads to the shore. *Photograph by Percy Loomis Sperr. Lee A. Rosenzweig collection.*

Two-story houses amid grass and sand in the northern part of the island, exemplifying the rural aspects of life on Barren Island, July 5, 1931. *Courtesy of the Queens Borough Public Library, Archives, Eugene L. Armbruster Photographs.*

roller skating, swimming, eating wild-grown food, tracking turtles across the sand dunes, row-boating and many other activities that were an ordinary part of his everyday life and that stood in contrast to the lives of immigrant children living in more urban parts of the city. Once runways were built on the island, Maier and other islanders would watch the planes take off and land, and for a few dollars they could go up for a ride with a willing pilot. Maier described a peaceful community in which the different ethnic groups mostly socialized separately but got along fine. "These people were very thrifty, hard-working people, I will tell you that. Got along very well," he said. He enjoyed school and, with Miss Shaw's encouragement, continued on to high school at Erasmus Hall in Brooklyn. He was disappointed when his family moved to a farm upstate in 1935 when he was seventeen, because there were no other young people around. Not once in his reminiscences did Maier recall anything about the smell, any health problems, crime or depression. Josephine Smizaski, born on the island in 1908, similarly remembered activities like swimming, fishing, row-boating, clamming, gardening, playing in the creeks and watching weekly movies at the dance hall. "No stealing, no nothing. Your doors were wide open." Like Maier's, Smizaski's memories of daily life were serene, relaxed and wholesome.[116]

Occasionally, reporters who could get past the smell would share a glimpse of the authentic experiences of islanders without the distortion of a lens of judgment. On November 10, 1912 (a few days after its interview with Policeman Evans), the *Brooklyn Daily Eagle* published an interview with an unnamed "prominent worker" on the island, giving him the opportunity to correct many misimpressions that had been spread in previous articles. He pointed out, "Everyone recognizes that this kind of work is important but they are perfectly willing to let someone else do it, and then look down on them for it," making a connection between the disgust for garbage and the disgust for garbage workers. He insisted that "the people are the most industrious to be found anywhere. Everybody works and saves money," and that Barren Islanders "are better than a lot of folks, and they live better lives. There are about 1,000 people over here, mostly Poles, Russians, with a small percentage of Italians, Swedes, Germans and other nationalities—all good folks, steady workers and good citizens." The worker was frustrated with the constant misrepresentation by outsiders: "How the idea got about that these people were different from the rest of the world is more than I can understand." And he understood that outsiders arrived for visits already prepared with stereotypes of what they thought they'd see: "You will find a lot of things you don't expect to find over there, and you'll hardly ever find what you expect!"[117]

Swimmers at Barren Island below dike for new airport fill, July 5, 1931. *Courtesy of the Queens Borough Public Library, Archives, Eugene L. Armbruster Photographs.*

In summary, Barren Island outsiders and insiders tended to have quite different perspectives on the island and the islanders. Especially with regard to smell, but also when it came to other aspects of daily life, outsiders generally saw islanders as depressing, semi-civilized, dirty, foreign people who were less worthy of notice or care than their better-off, American-born neighbors. This negativity arose from prevailing views of immigrants and foreigners, and also from revulsion at the type of work performed by Barren Island workers. At best, visiting outsiders saw islanders as quaint and picturesque but still very much alien. Since the islanders were not, in outsiders' perceptions, full members of the metropolitan society, it followed that they could be dismissed, ignored, forgotten—as indeed they often were.

Those who got to know Barren Island better had quite different views, admiring the islanders' thrift, honesty and independence. The islanders themselves were mostly happy and healthy. Nonetheless, the dominant views of outsiders had a major impact on the lives of residents. As mentioned in the introduction, the ingrained sense that garbage workers, who deal in disgusting materials, are in a sense disgusting themselves, is not unique to Barren Island but a common reaction. Hence, to better understand the experiences of Barren Islanders, it is important to understand their work.

3

WORK

*They work hard, it is true, in and around the reduction plant, at least the men do;
and their women folk seem to work just as hard about their little homes, while the
boys and girls, when they are not attending school, find plenty of occupation in
searching for hidden treasure in those huge heaps of refuse.*
—Sun, *August 15, 1915*

The terrible smells that so many neighbors objected to came, of course, from the industrial plants on the island. The workers in these factories processed menhaden into oil and fertilizer; boiled household garbage to extract grease; and dismembered dead animals to produce products ranging from bone ornaments to leather gloves to still more fertilizer. Each of these activities generated revulsion in many onlookers—not just toward the processes themselves, but also toward the workers who performed them. By putting the human beings who processed garbage in the same category as the garbage they processed, outsiders created the conditions whereby those human beings could easily be ignored by the rest of the city. Just as New Yorkers preferred their garbage to simply disappear, they also treated garbage workers as invisible.

Neglected by their fellow citizens, Barren Islanders rose to the challenge of fending for themselves. Since ferry service to Brooklyn depended on good weather, it was important for islanders to have access to local retail businesses for groceries and other basic needs. Some people turned a room of their house into a small shop. Visitors to the island and temporary

seasonal workers needed places to stay, so boardinghouses and hotels popped up. Before Prohibition began in 1920, the island's saloons were rather notorious hot spots of entertainment and occasional brawls. (By the time Prohibition was repealed in 1933, the island's population had shrunk markedly, and it was clear that the remaining factories would not last long.) And former residents recalled a number of other odd jobs, such as a saw sharpener and a man with a horse and wagon who could haul heavy loads.[118] Clearly, Barren Islanders were able to start businesses to meet demand for various goods and services.

In addition to these money-generating jobs and enterprises, islanders engaged in plenty of unpaid work to help satisfy their daily needs. Women undertook typical tasks of the time, like cooking, cleaning and raising children; but unlike most city residents, they also kept gardens and raised livestock for their families' use. Men, women and children all went fishing, clamming and crabbing. And children had particular tasks that were unusual for New York City kids at the time, like gathering driftwood for heating their homes and cooking. Finally, all members of the family—but apparently children above all—spent time scavenging through the heaps of garbage that littered the island. According to urban legend, "there is no child on the island without a ring from the Dump."[119]

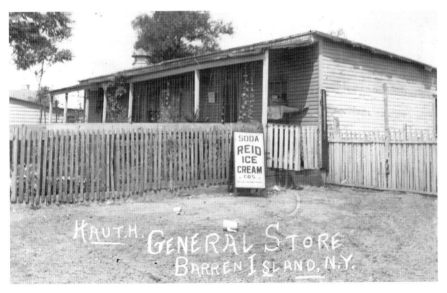

A typical retail store on Barren Island, located in a house, circa 1931. *Brian Merlis collection.*

Kevin Olsen has listed all of the factories that existed on Barren Island according to available records, from the 1850s until 1934. (DuBois cites an earlier date for the first factory: 1845.[120]) Some lasted a long time and even developed into dynasties, such as the Swift and White clan, which owned several factories from 1870 well into the twentieth century. Others were short-lived, like the Smith and Company menhaden factory, which lasted only from 1868 to 1871.[121] A few factories' histories have been almost entirely lost. An 1899 article in the *Eagle* referred to the "tin can factory," in which metal was melted and molded into 150-pound squares that were sold to the manufacturers of window sash weights.[122] It is difficult to find anything more than a passing reference to this unnamed factory anywhere else. And in the early days, there were also icehouses: storage warehouses for the large blocks of ice that were harvested from northern lakes and rivers in the winter and then sold south or back north in the summertime.[123] As with the tin can factory, few references to the icehouses survive, and since the work was seasonal, it is unclear whether any of their workers lived on Barren Island more permanently.

The first factories on Barren Island, in the 1840s or '50s, undertook animal rendering, and the "horse factory" was also the last to go, in 1934. By that time, the car had far overtaken the horse as a means of conveyance in New York City. But for many decades, thousands of horses a year were converted into a wide variety of products on Barren Island. Soon after the first factory on Barren Island opened, the *Eagle* explained:

> *The head bones are ground up and sold to the Gold Refiners, who make use of it for refining that precious metal. The ribs are converted into manure. The thigh, jaw and hip bones are calcined and used for refining sugar.... The shin bones are converted into buttons and umbrella handles; from the hoofs Prussian blue is made; and from the flesh Prussiate of potash is manufactured. The clippings of the hides are boiled into glue; the hair of the manes and tails undergo the curling process, and are used for stuffing mattresses. The remainder of the remains is converted into poudrette [fertilizer].[124]*

How were these remains prepared to be transformed into everything from umbrella handles to mattress stuffing? The same article summarized the process as follows:

> *A dead horse is brought to Barren Island by boat and dumped on the dock. Thence it is carted to the vicinity of the factory and is divested of its hide.*

The body is quartered and the fat is carefully separated and placed in a receptacle for that purpose. The mane and tail are cut off and put in a separate place, and the flesh is souzed [sic] into the large cauldrons for boiling. After this process the remains are divided and placed in separate heaps: The head bones; the ribs, thigh, jaw and hip bones; hoofs; flesh; clippings of the hides; hair, and manure.[125]

The approach of this article is the same as virtually every other description of animal rendering on Barren Island: it is written in the passive voice, as if these processes took place by some sort of magic or automation. The horse "is divested of its hide"—not "a professional skinner cuts the hide off the horse." Who did the divesting, the quartering, separating and cutting? In reality, all of these tasks were performed by human beings who did very hard manual labor in hazardous conditions for at least sixty hours a week, often more. It is quite striking how consistent reporters and other visitors were in their explanations of these processes, almost entirely omitting the people who made them happen.

Writers describe the work of fish factory laborers similarly. The menhaden industry boomed on Barren Island from the late 1860s until the end of the century, when the catch in the New York area diminished too much for it to be worthwhile. According to the *Eagle*, menhaden, which then swam in schools of millions in this area,

are an oily and bony specie unfit for food….As soon as the steamer has caught a load she returns to the factory, where the fish are cooked in large iron vessels. They are then put under hydraulic pressure and the oil pressed out. Then the refuse fish is placed on board platforms of one or two acres in size, where it is exposed to the sun's rays until thoroughly dried. Subsequently it is raked up and ground fine.[126]

Once again, it is as if an unseen hand must be responsible for all the things that happened to the fish. As further explained below, the manual labor in the fish factories was performed mostly by black men. While some writers pointed out this fact, most articles that focused on the processes themselves (as opposed to "slice of life" feature articles about the island) did not mention the workers at all, rendering these men invisible to readers.

The third major industry on the island, garbage rendering, was treated much the same way by those who recorded its processes. Garbage factories were present on the island off and on from the 1870s until 1919, when the

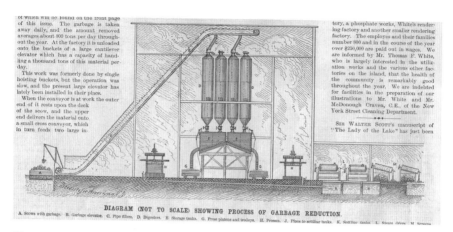

of which will be found on the front page of this issue. The garbage is taken away daily, and the amount removed averages about 800 tons per day throughout the year. At the factory it is unloaded onto the buckets of a large cantilever elevator which has a capacity of handling a thousand tons of this material per day.

This work was formerly done by single hoisting buckets, but the operation was slow, and the present large elevator has lately been installed in their place.

When the conveyor is at work the outer end of it rests upon the deck of the scow, and the upper end delivers the material onto a small cross conveyor, which in turn feeds two large in-

tory, a phosphate works, White's rendering factory and another smaller rendering factory. The employés and their families number 800 and in the course of the year over $250,000 are paid out in wages. We are informed by Mr. Thomas F. White, who is largely interested in the utilization works and the various other factories on the island, that the health of the community is remarkably good throughout the year. We are indebted for facilities in the preparation of our illustrations to Mr. White and Mr. McDonough Craven, C.E., of the New York Street Cleaning Department.

Sir Walter Scott's manuscript of "The Lady of the Lake" has just been

DIAGRAM (NOT TO SCALE) SHOWING PROCESS OF GARBAGE REDUCTION.

A. Scows with garbage. B. Garbage elevator. C. Pipe fillers. D. Digesters. E. Storage tanks. G. Press platens and trolleys. H. Presses. J. Pipes to settling tanks. K. Settling tanks. L. Steam drive. M. Screens.

Diagram showing the process of garbage reduction, from the lifting of garbage from a scow (A) to its "digestion" (D) and screening of the remaining solid items (M) to separate them from the powdered fertilizer that the process created. *From* Scientific American, *August 14, 1897.*

last plant was closed. At times, garbage processing was shut down, either because of disasters like fires, or because the city forced the factories to close temporarily to deal with odor complaints; at these times, garbage was dumped at sea. When they were in full swing, garbage factories produced mostly fertilizer, as well as grease that was sold to companies that turned it into soap. A typical description read:

> *After the digesters are filled with the garbage, they are hermetically sealed and steam at 50 pounds pressure is admitted through the lower cone. The cooking is allowed to go on for a period of eight to ten hours, until the garbage is thoroughly disintegrated and reduced to a pulplike consistency, all germs in the meantime being thoroughly destroyed. The matter is then dropped into twelve storage tanks....Upon the platen is placed a mould or outer frame which is covered with burlap, and after a sufficient amount of the material has been run into the burlap to fill up the mould, the burlap is folded over above it and covered with a rack or wooden gridiron about 1/2 inch in thickness.*[127]

As with animal rendering and fish processing, this writer presents garbage processing in a passive voice, distancing the reader from the workers and allowing (or perhaps even encouraging) the reader to forget that the workers exist. Just as New Yorkers preferred not to think about their garbage, they also preferred not to think about the people who dealt with their garbage after it had been thrown out.

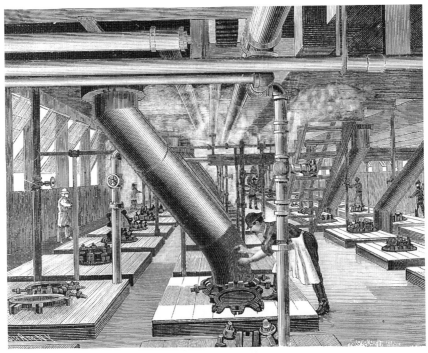

TOP OF DIGESTER ROOM SHOWING PIPE FILLERS.

The upper level of the digester room at the New York Sanitary Utilization Company factory on Barren Island. The garbage was "cooked" with steam in the digesters (below the pipes shown here) for eight to ten hours. *From* Scientific American, *August 14, 1897.*

Steam jacketed driers at the New York Sanitary Utilization Company factory on Barren Island, where the compressed garbage was dried and pulverized. *From* Scientific American, *August 14, 1897.*

But the workers did exist. The people doing all of this factory labor were the male residents of Barren Island. As the population increased, occupations diversified somewhat and small retail shops emerged, as discussed below. But throughout the island's history, most of the men worked in the factories. Indeed, in 1877, a *Brooklyn Daily Eagle* reporter visited the island and found that "with the exception of the hotel keeper, every person on the island is connected with the rendering establishment."[128]

The men were not distributed equally among the different jobs. Frederick R. Black analyzed 1880 census data for a National Parks Service report and observed that at Coe's Fertilizer Factory, there were "thirty-one white male laborers, nineteen born in Germany, five in Ireland and seven in New York," while "at John E. Jones' factory, a fish oil works, there resided forty-five laborers, all male, single, black, and born in Virginia." These black workers were supervised by ten white managers.[129] This pattern of racial segmentation, with black workers confined to lower-level jobs at the fish factories, appears to have persisted until the decline of the fish-oil industry in the late 1800s. An 1880 classified ad in the *Sun* announced: "Wanted—Six colored men to work at fish factory on Barren Island."[130] A reporter who visited a fish factory in 1888 wrote, "Outside were great floors of wood, where negroes raked immense masses of dead fish back and forth under the hot sun till they were as dry as pieces of chips. They laughed and talked over their work, and looked happy and contented. They came from Richmond, Va., and some of them had been at work on the island for fifteen years."[131] Reiterating this perception of black workers as docile and submissive, another reporter wrote in 1894 of the menhaden factories: "The factories are usually worked by colored hands brought on from Virginia. These men work for small pay and are steady and sober, never leaving the works until the season is ended, when they receive their pay and return to their homes in the South."[132]

The black population of the island shrank—but did not disappear—when the fish factories closed. Later census reports continued to show a small but stable black population. The men worked in the garbage and fertilizer factories. For example, in 1910, fifty-one black residents were recorded, most of whom were born in the South. These included a garbage plant foreman, George McDowell, born in North Carolina, as well as many garbage plant laborers and "muckers," vat tenders at the fertilizer factory and a school janitor, George Bertha, born in Virginia. Many of these men had wives, most of whom were listed as having no occupation, and children. One black woman, Ada Rouse, born in Virginia, was a "cook for a private family."[133]

As these records show, once the fish factories closed, owners of the other industries on the island were willing to hire black workers, sometimes (though rarely) even in supervisory positions.

The white workers were mostly immigrants. Newspaper articles occasionally referred to large numbers of "Dutch" or "Swedes," apparently erroneously, but most reports as well as census records confirm that the primary countries of origin for white workers were Poland, Germany, Italy and perhaps Russia, with a smattering from other countries in Europe. The changing borders in Eastern Europe during this period can make it challenging to pinpoint specific origins, and some people were listed as "Russian Poles." Polish appears to have been spoken much more commonly than Russian, and was the language of the local Catholic church. Some evidence suggests that some islanders came directly from Ellis Island to Barren. For example, a 1912 article stated, "A large number of the Slavs went to the island from Ellis Island direct, and they know little or nothing about the rest of the country."[134] Another article from the same year also reported that "many of the workers on the island come direct from Ellis Island."[135] Assuming that this information is correct, it can be inferred that either there were labor recruiters for Barren Island factories on Ellis Island, or that some immigrants were able to arrange for Barren Island jobs before their arrival in the United States (an illegal but common practice).

Just as the black workers' race was identified in articles as described above, the national origin of white workers was often named as well. In an 1899 article about a strike at Coe's fertilizer factory (described in more detail below), the reporter stated that "the laborers are, for the most part, Poles and Hungarians."[136] A 1913 article in the *Sun* about another strike stated, "the men are Russians and Polacks, most of them." Other articles about this same strike consistently refer to the workers as "Poles" or "Polacks."[137] The convention of referring to the workers' race or ethnic origin reinforced the sense of these workers as separate from mainstream Americans, people who were different and who might naturally be treated differently.

These workers were exposed to many occupational hazards. This was a time before workplace safety regulations, and newspapers reported regularly about accidents, sometimes fatal, at Barren Island factories. The tone of these articles implied that accidents were simply an inevitable part of this kind of work; there was no suggestion that safety rules ought to be implemented or that workers or their families were due any compensation.

PRESS ROOM.

The press room of the New York Sanitary Utilization Company factory on Barren Island, where remaining liquids were pressed out of cakes of garbage, reducing them from four feet tall to eighteen inches. *From* Scientific American, *August 14, 1897.*

Newspaper reports were sometimes matter-of-fact and sometimes rather dramatic. One accident in 1885 generated articles of both kinds. The *Sun* reported simply that "the boiler in ex-Senator Coe's fish factory on Barren Island exploded yesterday morning, and five men, one of whom will probably die, were scalded."[138] The *New York Times* described the same accident at greater length and with more drama:

> *While six men were at work in Coe's fertilizer factory at Barren Island shortly before 10 o'clock yesterday morning a deafening report came from the engine room, and in a second the whole place was enveloped in steam and boiling water was flying in every direction. The engine boiler had exploded. Constantine Peterson and Michael Cooley, laborers, were at work near the boiler at the time of the explosion, and were knocked down by the force of the shock and unable to escape from the mass of hot water which flowed over them. Three others of the men were badly scalded.*[139]

Neither article, however, suggested that anyone was to blame or that the accident could have been avoided.

Scalding was an accident that happened repeatedly, perhaps not surprising in light of the extreme heat needed for both garbage processing and animal rendering. In 1897, "Edward Bogan, 46 years old, was severely scalded at 2 o'clock this morning by escaping steam, while at work in the garbage crematory at Barren Island. He was taken to the mainland in a steam launch and from Canarsie in an ambulance to St. Mary's Hospital."[140] Again in 1910, six laborers (one identified as "colored," the rest presumably white) were "terribly burned and scalded," this time at the Sanitary Utilization Company, when an explosion "destroyed the condenser and digestive plant" after "the immense vat in which…refuse is poured must have been overloaded yesterday by the workmen."[141]

The type of work done in the Barren Island factories also led to other kinds of dangers. In 1892, Peter Dillman, a fertilizer factory worker, died of glanders—a disease that normally affects horses. The *Evening World* reported that "Dillman was employed by the fertilizing company at Barren Island to skin the carcasses of horses, and it is believed that he contracted the dreadful disease there. The progress of the malady in his case was very similar to that in the horse, and he suffered the greatest agony before he died."[142] More common than disease were industrial accidents. In 1896, "Julius Machk, a machinist…while at work in the employ of the New York and Brooklyn Sanitary and Fertilizer company on Barren Island yesterday afternoon, had his arm torn off by the machinery. He was taken to St. Mary's hospital in a critical condition."[143] And in 1910, a man was "ground to pieces" at the Sanitary Utilization Company when he fell or was pushed into a conveyor.[144] Just a few months later at the same factory, a worker fell from an elevated structure that carried coal that was the fuel for the machinery. "He was badly hurt.…The doctors hold out very little hope for his recovery."[145] Four more fatal accidents were reported within less than two years of that one.[146]

As these examples demonstrate, the accidents and illnesses that were caused directly by Barren Islanders' work did not generate outrage, at least as expressed in news reports. The awful smells that these factories produced, which affected residents of other communities, were often described with great fury and intensity. But the deaths of Barren Islanders in the course of their daily work, even when reported in dramatic prose, did not lead to any public outcry or call for change in working conditions there.

The workers themselves did sometimes call for change. A number of small and large strikes occurred on Barren Island over the years, though they were

The grease-settling tanks on the lower level of the New York Sanitary Utilization Company factory on Barren Island. Grease would rise to the surface and was then pumped into barrels and sold to industrial concerns all over the world to make soap and other products. *From* Scientific American, *August 14, 1897.*

focused not on worker safety but on wages and related issues. Island workers were not formally organized. However, four strikes were reported by New York newspapers between 1887 and 1913, and the workers appear to have been relatively successful in uniting to stand up for their demands, mostly without outside union help. The first three strikes were modest in scale, while the last led to a "riot" involving hundreds of striking workers, replacement workers and police officers. This series of labor actions shows how a group of mostly foreign and black workers were able to exercise what little power they had to gain better compensation for their work.

In September 1887, "about 125 men employed in the Fertilizing Factory of E. Frank Coe, on Barren Island, went on strike…because of dissatisfaction with the quantity and quality of food furnished them by the company."[147] The strike apparently got immediate results, as Mr. Fairchild, the plant superintendent, "said that he would see that their request was granted. The men returned on Thursday to work and are now satisfied." The factory management clearly wanted to prevent any further grumbling: "It was feared that the action of Coe's men in striking would be followed by a strike of the men employed in other factories, but Mr. Fairchild's prompt action has put an end to all dissatisfaction." Since this action was a quick acceptance of the workers' demands, the owners must have calculated that the cost of more and better food was less than the potential for trouble if they did not grant the request.

The next two reported strikes both took place in 1899. In June of that year, again at Coe's factory, twenty-five workers struck because of a cut in pay of

a penny an hour, or sixty cents a week. Coe's hired replacement workers, "but some of the strikers got hold of them and induced some of them to go home.…The strikers declared that they had no intention of destroying any of the company's plant but they asserted that they would do all that they could in an orderly way to prevent anybody else from working there." The reporter sounded a bit surprised by the workers' audacity: "When the men heard that the employers had declared that there were enough men in the factory to carry on the work they boldly exclaimed 'Ha, ha!' and asserted in addition that the works were badly crippled and that the employers would be forced to take them back." The factory called in police captain George Buckholz of Canarsie to address the workers. He "gave them a fatherly talk" and returned to Canarsie.[148] Unfortunately, the outcome of this strike is unknown. Regardless of whether the workers' demands were met, however, it is clear that they felt capable of standing up to their employers, even in the face of the hiring of replacement workers. There is no indication that they had help from any outside labor organizers.

A few months later, at the New York Sanitary Utilization Company, three hundred workers missed their payday. Three days later, when there was still no money forthcoming, the workers told their bosses that "they had been waiting long enough…and as the money had been long overdue they had determined that they would not go to work until they got it.…It was the intention of the managers to pay the men to-morrow.…The manager declared that the firm was perfectly responsible and solvent and that there would be really no trouble about it. On this representation about one hundred and fifty of the men went back to work and the others refused."[149] This seems to have been the end of it; presumably, the men got paid the next day and things went back to normal.

These relatively peaceful and quick strikes were quite different from a much lengthier dispute at the same company in April and May 1913. According to the *Sun*, 150 of the plant's 300 workers, "mostly Hungarians and Poles, [were] striking for shorter hours and more pay." This time, they had outside assistance. "A delegation of the strikers called at the New York office of the American Federation of Labor yesterday and asked that an organizer be sent to them. Hugh Frayne, general organizer of the federation, designated Joseph Tylkoff, a Hungarian organizer, to take charge. The strikers will be formed into a union to-day."[150] The dispute was mainly about wages. While the workers had previously been paid $22.50 per week during busy times of year, and $18.00 during less busy periods, they now demanded $22.50 year-round. The company accepted this demand "after several conferences," at

which point the workers asked for $25.00 per week year-round. This the company would not consider, and the strike continued.[151] (Other reports mentioned somewhat different details on the wage dispute, but wages were clearly the impetus for the strike.[152])

Two days later, the *Eagle* reported that the strikers had withdrawn their second demand and the strike had ended. But the agreement didn't hold: a month after that, there was a "riot" in which "a mob of 300 strikers… carried on guerilla warfare with seven police defenders of the New York Sanitary Utilization Company's plant." This event took place after factory management brought in replacement workers. It was the only reported instance of a violent labor dispute in Barren Island's history. The workers, described by the *Eagle* as "infuriated striking Polack laborers," were "armed with revolvers, bottles, bricks and other make-shift weapons.…Before the battle was over one of the strikers was shot through the hand, several others less seriously injured, five of them were captured and considerable damage was done to the garbage disposal plant. Although a fusillade of bullets and bricks rained about their heads, all of the police escaped uninjured." Being severely outnumbered, the police called for reinforcements by telephone. Here the island's remoteness again played a role. The police boat bringing additional officers broke down and reached the island only hours later, "when the fighting was practically over."[153]

All of the articles about this strike stressed that it could lead to garbage being dumped in the ocean and probably washing up on nearby beaches, which would disgust beachgoers. There is a clear sense that the garbage workers were causing trouble for the innocent citizens of the city. In a description of the riot, the *Eagle* reporter wrote, "When the riotous strikers saw how small a force of police was on hand, they turned their attentions entirely to the little band and rushed on them with blood in their eyes."[154] The *New York Times*—mentioning a figure of five hundred rather than three hundred strikers—reported, "The seven policemen were no match for the force of strikers, who, inflamed with Barren Island liquor, were wild with rage."[155] Given that no police officers were injured and several strikers were, one must take these descriptions with a grain of salt. Following the riot, the *Evening World* stated of the strikers that "the foreign squatters are maintaining a sullen attitude of defiance."[156] The sympathies of the newspapers were transparently with the police and with the city's dilemma about how to dispose of the garbage in the face of the strike. None of the nine articles about the strike in four different newspapers delved into the question of whether the workers were being paid a reasonable wage.

Consistent with their treatment in other facets of life, Barren Islanders were once again viewed in a negative light, as a perhaps necessary but definitely unpleasant nuisance—much like the smells that their work produced.

The factories provided work and, sometimes, food. But they provided nothing else, in terms of either goods or services. Although islanders could, in theory, take the ferry to Canarsie to shop, this was a highly unreliable and always time-consuming option. In bad weather, as already shown, the ferry would not run or could take hours to reach its destination. So, as the island's population grew, residents began to see entrepreneurial possibilities in providing for their neighbors' basic needs. These business owners included both men and women.

As mentioned above, in 1877, an *Eagle* reporter could find none but factory workers on the island save for one hotel keeper. Soon after that, however, businesses began to open. In his report on Barren Island, Frederick R. Black notes that, by 1900, "some men had occupations unconnected to the island's industries. There were a number of barbers, butchers, grocers, dry goods merchants, and bartenders. Five men managed hotels, and fifteen persons, some of them women, ran boarding houses."[157] An 1899 feature article in the *Sun* stated: "In some of the houses one room is used as a shop, and altogether there are about fifteen of such places, a grocery, which contains the post office, a dry goods store, an apothecary's shop, a notions store, a shoe store, a dressmaking parlor, a barber shop and four or five saloons. There are also two or three boarding houses."[158] Though Black and the *Sun* article differ in the number of boardinghouses, the general picture is clear: the island now hosted a variety of businesses to cater to residents' basic needs, from clothing to haircuts to liquor.

Former resident William Maier remembered many such businesses a generation later, in the 1920s. He would buy an unusual combination of snacks from the grocery store: an ice cream cone and a sour cucumber. "I could remember that storekeeper, Mrs. Smith, [would] say, 'Willie! Are you going to eat the ice cream and the sour cucumber?' And I said to her, 'I sure will! And I'm going to enjoy it, too!'" Maier also remembered his mother sending him to the butcher shop. Mrs. Smith of the grocery store seems to have run a miniature business empire on the island, as she was also the postmistress and had "a restaurant houseboat," where Maier suspected her of "selling a little beer and whiskey on the side" (this was during Prohibition).

Others took advantage of the seafood available for the taking near the island. Maier remembered a Mr. Gunyan (Gunyan is a name found in island census records, with different spellings, for many decades) who had a seafood-trapping business. Islanders could order what they wanted from

among his live captives: "When he emptied his traps, he didn't have to kill whatever he caught, whether it was lobsters, or blue claw crabs, or fluke or flounder, tommycods, all different kinds. He'd just throw 'em in there [a caged-in area in the water], you know? Anybody want to buy a fish, he'd get his net and fish 'em out." And there were other odd jobs that served the needs of the residents. Maier recalled, "They had an old man that lived somewhere in this area....He was a saw sharpener. He was a real old man. He sharpened saws, that's what he did for a living."

Other paid work was available for those who knew how to find it or to create their own opportunities. As a child, Maier would make some change here and there in a number of ways. "I had a little job here for the teachers. I was able to empty the ashes from their furnace. I always remember I used to dump them back out here. She had a cat, too, that principal. I used to feed her some kind of tins—sardines or salmon.... She asked me to feed the cat, so I made a few cents that way." Another money-making venture—a "dishonest" trick in his own words—occurred to the teenaged Maier and his friends once the airport was up and running. Visitors would drive along the Flatbush Avenue extension to watch the planes take off and land. Maier recalled:

> *The cars parked, they'd park in the sand, and of course they got caught in the sand sometimes, spinning, they'd get stuck. And of course us young boys were there, we'd give 'em a push and out they went....We'd say, 'Okay, give it the gas!' We'd hold back, so they'd start spinning again, deeper and deeper. So...of course, we all had the scrap lumber, we'd run home, we'd get a shovel and get the boards and stuff, and put it. We'd do a little extra work, now these guys felt a little [bad], so when we got 'em out, they'd give us a nickel or a dime.*

The boys' knowledge of the sandy environment helped them take advantage of outsiders and earn a bit of change.

Maier's father worked as a skinner at the horse factory, and his mother, along with keeping house, found a number of ways to contribute financially. "She was making always a little money on the side," as Maier put it. She helped the school janitor clean the classrooms, and later, she took in laundry (although "they never paid her half the time"). Maier's recollections, along with news reports over the years, help create an image of a thrifty population alert to many possible ways to supplement a household income whose mainstay was factory wages.

Of course, Barren Islanders, like anyone else, had to perform many different types of unpaid work in order to take care of their households. Much of this was similar to work that any New York City family would have done, like cooking, cleaning and raising children. However, Barren Islanders also did many other sorts of work that were quite unusual for an urban population: raising livestock, gardening, gathering driftwood, building houses, searching for clams and, of course, scavenging—searching for useful items among the mounds of garbage dumped on the island every day. The *New-York Tribune* quoted a little girl on the island in 1921 as saying, "Barren Island is the best place to live. You can spear fish and swim and pick up your wood."[159]

Little information about house construction on the island is available. As mentioned in chapter 1, the first housing consisted of company dormitories, presumably built by workers hired by the factories. Soon, though, single-family houses began to be built. William Maier recalled, "Most of these older buildings were built of clapboard. They were more, as you see, of a bungalow-type building. Nothing fancy. I think they were built not with blueprints. Whoever built them were I think just handymen and took advantage with the lumber they had on hand and came up with basically a roof, a side, and rooms, and maybe a few windows." Though Maier's theory was speculative, and other sources about housing are not available, it is certainly plausible that ordinary islanders built their homes themselves or perhaps hired minimally skilled workers to perform that task. Based on the hands-off approach that the city and the factories took toward the islanders' basic needs, that is the most likely way that houses were constructed.

Many visitors commented on the ubiquity of kitchen gardens and chickens, ducks and pigs on Barren Island. A reporter for the *Sun* in 1899 wrote, "many of the families manage to have little gardens in summer, making the soil for their flowers and vegetables by mixing the fertilizer with the sand."[160] In 1901, writing to the *Eagle* to contradict a very negative article about the island, principal Daniel T. Edwards mentioned the "pretty gardens attached" to most homes.[161] William Maier remembered that his neighbor in the 1920s "had a couple of chicken coops, and he used to send me out to gather his eggs." In 1930, Jane Shaw told a reporter from the *Eagle* that "every one raises his own vegetables.…Most of the residents have their own chickens, ducks, and cows."[162] Raising one's own vegetables and livestock was the only way to provide fresh food for the family. The hogs kept until the New York State Board of Health's 1909 visit, described earlier, were another way that islanders produced fresh meat. Because of the inconsistency of transport, importing fresh food from the mainland was unreliable. Despite

Laundry drying near the end of Board Road, Barren Island, April 21, 1931. *Photo by Percy Loomis Sperr. Lee A. Rosenzweig collection.*

Shaw's statement, for most of the island's history most residents did not own cows, and as the *Sun* reported, in the days before refrigeration, "condensed milk [took] the place of the fresh article almost exclusively."[163] The 1915 article about the Americanization program for immigrants states that the provision of fresh milk was "a welcome substitute for the condensed or 'turned' milk on which babies had previously been fed."[164] The reliance on condensed milk is a good example of the nonexistence of fresh food on the island aside from that which islanders cultivated themselves.

The fact that Barren was an island made it a good place to get food from the sea. William Maier said that he and other residents fished for snapper, shiners, killies, fluke, flounder, tomcod, crabs, clams and even lobster. Josephine Smizaski remembered her father fishing at night—"they'd get quite a bit." Some of the clamming was illegal because of pollution; if caught, islanders would claim that they were only going to use the clams for bait, though Maier's memories show that this was not always the case. It seems likely that islanders regularly ate locally gathered clams and only rarely got caught by the authorities.

Children on the island had special tasks. The *Sun* reported in 1899, "The children are perpetually engaged in a search for pieces of wood, or anything which will serve as fuel."[165] Twenty-five years later, William Maier was engaging in the same search for driftwood. He recalled:

Everything was heated by wood, cooked by wood. My job—of course, we had to go down and get driftwood. All along this particular part of the beach,

where for some reason, all the wood seemed to come in this part of the beach, like a magnet. So much—barrel staves, baskets, crates, broken lumber, parts of boats, they'd make a pile. Then we had these two sticks, maybe six foot long, and we made like a stretcher, and my mother would stack all the wood. She'd go on the back end, and I'd be on the front end, and we'd take the wood home. When she was busy, she used to send me down.

And by all accounts, the children loved to scavenge in the garbage piles. Adults, too, engaged in the daily search for treasure, or at least for reusable or resalable items. The *Sun* reported in 1899 that "coal is gleaned from the garbage, and it sometimes happens that substances of greater value are found. On two or three occasions lucky youngsters have fished out valuable jewels from the refuse, although, it should be stated, it would not be easy to make a living by picking gems and jewels from the materials which are sent to Barren Island's fertilizer factories."[166] A "prominent worker" told an *Eagle* reporter in 1912: "When carts come from the factory they are followed by the boys and some of the women, who carry bags and picks. The dump is worked by the pickers with amazing results. It is a regular gold mine, silver mine, brass and diamond mine, and every other kind of mine."[167] In 1916, an *Eagle* reporter visited and spent quite a bit of time with the scavenging children and families, writing that even young children knew how to acid-test metals to see if they were precious. The reporter was quite taken with the "picturesque" dump ("the setting for the never-ending treasure hunt") and its denizens, noting that each family specialized in a particular type of debris (such as bone, metal or rags) and would help each other out by passing finds to the appropriate family.[168]

In 1919, the garbage plant closed, leaving the "horse factory" (as it was universally called) the last one open. According to news reports, the children were bereft without a new supply of garbage. The *New-York Tribune* stated: "Miss Shaw tells the story of the fairy wish of the little Barren Islanders. It was Christmas. She drew her children about her. 'Now,' said she, 'if you had a fairy godmother who would give you anything you wanted, what would you ask?' The answer came in unison; 'The garbage back. We'd wish the garbage back.'"[169] The garbage, one of the main reasons the island community existed at all, held a very different and incalculably more valuable meaning to the islanders than it did to those who had discarded it.

Barren Island residents came there almost exclusively to work in the factories, or because a family member did so. The work, which was essential to the functioning of New York City and also dangerous, consisted

A group of children in aprons with large pockets scavenging through a mountain of trash, looking for valuables, circa 1904. *Lee A. Rosenzweig collection.*

of processes that many others found revolting. This repulsion helped to rationalize neglect of the island by the city. Because of this neglect and the island's relative remoteness from the rest of the city, Barren Island residents saw business opportunities fulfilling the needs of their neighbors. These enterprising residents realized they had the rare opportunity of a captive market and opened many small retail stores.

Much unpaid work also took place on the island. These included typical urban women's work of the time, but also tasks associated with rural and marine areas, as well as garbage scavenging. These tasks, too, show the initiative taken by islanders to better their lot through subsistence and small-scale economic activities. For example, they responded to the difficulty of getting fresh meat from the mainland by fishing and gathering shellfish.

When it came to work, Barren Islanders demonstrated diligence, flexibility and resourcefulness, as well as the willingness to stand up for their rights when necessary. They were able to turn the city's neglect of their needs into economic opportunity. The islanders' creative approach was also apparent in their daily life outside of work. In spite of (and sometimes because of) their unusual isolation, islanders found many ways to entertain themselves both on and off Barren Island. They also practiced their religion when the opportunity arose. Barren Islanders' experience of recreation and religion form the subject of the next chapter.

4

RECREATION AND RELIGION

This was my life, I'd say…clamming, fishing, just sightseeing, looking,
standing on the docks, going exploring.
—William Maier, former Barren Island resident, interviewed in 2012

Barren Island…is cited as a fruitful field for sincere missionary effort by those
organizations of one denomination or another which so generously provide
medical missionaries, teachers, preachers…for other islands than Barren—isles
of the South Pacific, for example, as well as for Eskimos of the polar region, the
inhabitants of India, central Africa and many others in remote parts of the world.
—Sun, August 15, 1915

O n January 27, 1918, the *Brooklyn Daily Eagle* published an article
about a surprising occurrence. Harold Rohde had driven a truck
from Canarsie to Barren Island! The region was in the midst of a
cold spell, and Jamaica Bay had frozen over. Rohde, who had "large oyster
and clam interests on Jamaica Bay," covered five miles over ice of unknown
thickness, along with a friend driving a car. After driving through a "tin
can dump—seemingly millions of cans of all sorts and sizes…both truck
and touring car went…on through the little village, startling the animals
and amazing the populace, of whom fully 90 per cent, had never seen an
automobile." Rohde and friend gave the islanders rides and then drove back
to Canarsie, with several islanders flying along behind after having attached
their sleds to the vehicles.[170]

Riding in a Speedwagon on Barren Island, July 5, 1931. *Photo by Percy Loomis Sperr. Lee A. Rosenzweig collection.*

Although many daily activities on Barren Island were the same as they might have been anywhere else at the time, many others were determined by the area being an isolated, almost rural community that was sporadically cut off from the mainland. Within this context, Barren Islanders came up with many forms of recreation and entertainment that they regularly engaged in on the island. At times, they went off the island for recreation, and these were considered quite memorable occasions, recalled vividly by former residents and even written up in newspaper articles. Another aspect of daily life on the island was religious observance. A Catholic church, as well as a nondenominational Protestant chapel, existed on the island starting in 1900. These institutions, especially the Catholic church, also formed part of many islanders' daily lives.

In order to get a sense of the circumstances of these quotidian experiences, it is important to keep in mind the fact that for most islanders, Barren Island was a place separate and apart from the rest of New York, one that they rarely left. Many residents and observers alike emphasized that point. In 1899, the *New-York Tribune* reported that many residents "were born there, and have never known another home, and there are those who have not

been to the mainland for twenty-five years."[171] William Maier, who lived on the island from his birth in 1917 until he was eighteen, remembered one trip to Canarsie as a child. He said that, otherwise, he "never left the island. If it wasn't for going to [high] school in my later years, in the '30s, I would've probably never left the island."

Travel off the island was, in any case, always dependent on the weather and the functioning of the ferryboat. Newspaper articles reported many outages over the years. In 1885, the boat was taken out of service for ten days for repairs.[172] More commonly, bad weather was the cause for cancellation. In a typical story, in February 1895, the *Evening World* reported that "on Barren Island there are four or five hundred people who have not been reached since the storm [days earlier], as the boats which run there have been prevented by the weather from making their usual trips. A journey there by boat at the present time would involve all the perils of an Arctic exploration." Two days later, there had been no change: "The people on Barren Island are still isolated."[173]

This isolation was reinforced by hazards. There were many boating accidents nearby, most of which didn't involve Barren Islanders, but they certainly heard about them. Sometimes, they were called in to help with rescue efforts. In August 1882, a boat capsized off Barren Island, and "the party were all rescued" by Adolph Wimpfheimer, a factory foreman who had also "saved four men who were capsized at nearly the same spot" the previous spring.[174] Another dramatic tale, more unusual, was that of two young men who went to "their favorite eeling ground on the north shore of Barren Island…[when] a large rowboat, in which there were four rough-looking men, glided suddenly up alongside out of the darkness. The…boys at once realized that they had struck a gang of river pirates who had been infesting the bay all winter…the four pirates, jumping up and uttering loud and direful oaths, began an onslaught on them with their oars." After a "battle" lasting several minutes, the boys escaped.[175] More common was the difficulty caused by ice, which could cause boats to be stuck fast and could damage both boats and docks.[176] Sometimes, people would attempt to walk across the ice between Barren Island and Canarsie. This also presented dangers, as in the case of a twenty-year-old Polish immigrant, Drenussia Gricinia, who froze to death trying to visit her uncle, a Barren Islander.[177]

Even in later years, after the island was connected to the mainland of Brooklyn via the Flatbush Avenue extension, its remoteness could be hazardous. In 1927, a visiting fisherman, Christopher Bauer, heard a dog barking all day long. He finally went to find it and discovered a man stuck in

quicksand near Deep Creek, which was "frequently used by eel fishermen. At low tide it is muddy but safe. The rising water transfers it into a trap of quicksand." Bauer rowed back to Brooklyn for help and returned by boat with a policeman, who helped rescue the man, who was "more dead than alive."[178] Three years later, a sixteen-year-old boy named Edward Foley went hunting in the meadows on Barren Island and found himself stuck in quicksand as well. He, too, was lucky to be discovered by a passerby and rescued by a police officer.[179]

Barren Island's remoteness, and the dangers that islanders knew they faced as a result, necessitated the ability to create opportunities for fun and entertainment right there on the island. Many of these involved taking advantage of the island location. Former residents Josephine Smizaski (resident on the island from 1908 to 1918) and William Maier (from 1917 to 1935) both fondly recalled swimming in the ocean and fishing for recreation. They also both remembered bonfires on the beach for Election Day and the Fourth of July. "The clamming, the rowboating, the fishing—oh!" Maier remembered. Just wandering around the island could be a satisfying form of recreation. "My folks seemed to let me roam a lot," Maier said. "My mother always said…'Yeah, Willie, he loads up. He takes all my prunes and apricots and raisins and apples, he loads up and he's gone half of the day.'"

There were also many recreational activities, both for children and for adults, that were brought to the island and became part of residents' daily lives. Maier remembered roller-skating in the school basement in the evenings, after Jane Shaw obtained a donation of roller skates for all the children. Josephine Smizaski remembered the dance hall, which was also mentioned in several newspaper articles—sometimes as a site of immoral behavior.[180] Children played sports; there was a baseball team and a field, and Maier remembered playing handball in the abandoned garbage factory buildings after that industry shut down in 1919. Sometimes, kids just hung out and watched the world go by. After the Flatbush Avenue extension was built in 1926, Maier said that he and his friends would watch the cars and quiz each other on the makes and models.

Adults were enthusiastic visitors to taverns in the years before Prohibition began in 1920. After that era began, residents adapted. Maier remembered his mother making home brew "with hops and malt on the kitchen stove." His father would store the beer under the house in a cellar he dug himself, and "every once in a while, you'd hear one of those sons of a gun explode." Another former resident, Edward Kishkill, remembered a weekly party "at the one building suitable for it, a tavern where a man named Mooney

Men playing baseball near the garbage plant, 1931. *Courtesy of the Queens Borough Public Library, Archives, Eugene L. Armbruster Photographs.*

Zemzitzky banged on the piano, though he could not play a lick, while his brother played the clarinet."[181]

There were also more sedate pursuits for children and adults alike. Maier remembered his mother visiting with other German immigrant mothers on the island, and his father would have friends over on Sunday afternoons (probably his only day off) to smoke Italian cigars. Families listened to the radio, including prize fights, and he and other former residents recalled watching silent movies via electricity supplied only to the school, the teachers' cottage and the janitor's house. "Weddings were weeklong celebrations in which every household cooked dishes," recalled Kishkill.[182] Some residents raised homing pigeons. In general, Barren Islanders "were content to spend their evenings at home…keeping warm, and feeding their children," said Maier.

With the preparations and opening of Floyd Bennett Field in the 1920s and '30s, opportunities arose for quite new forms of entertainment. Maier had vivid memories of observing and exploring the heavy equipment and materials used when the land was filled, dredged and leveled for the airport. Once the planes started flying, kids would gather and watch them take off and land. They got to know the pilots. Kids would create mini-parachutes out of handkerchiefs tied to rocks and persuade student pilots going up for short flights to drop the handkerchiefs from the planes. For a few dollars, pilots would

Looking south on Broadway on Barren Island. *Brian Merlis collection.*

take people up for a flight. And islanders would watch the parachute jumpers. "In those days, they couldn't control the parachutes. Half the time you landed in Jamaica Bay," said Maier. He remembered seeing many famous pilots land and take off at Floyd Bennett Field. Island life, which had been so remote and in many ways primitive for so long, now suddenly included the most up-to-date aviation technology in the world.

Yet, in spite of the presence of pilots taking off on thousand-mile trips, the islanders themselves were still mostly isolated. The occasional group trips off the island were often described, at least by outsiders, as dramatic, seminal events in their participants' lives. An 1899 article in the *Brooklyn Eagle* described the "second annual excursion of the Barren Island Church."[183] The one hundred women and children, and one man, on the excursion went to Rockaway Beach for the day. "Among the excursionists was Mrs. Gunyan, who has lived on Barren Island for forty-seven years. She is the oldest inhabitant of the island. She has a pretty home at the extreme end, toward Coney Island. Tuesday's outing was her third trip to Rockaway, and she has never been to Coney Island, although she could easily row there." Three years later, two hundred children (though apparently not Mrs. Gunyan) got their chance to go there with the Catholic priest Father Thomas Horan, who visited the church on Barren Island weekly for Mass. This outing, to

Tilyou's Steeple Chase Park, was sponsored by the president of the Brooklyn Sanitary Company, which employed many of the children's fathers.[184]

Group visits off the island were not reported again until the 1920s, when principal Jane Shaw began working with other officials to give the Barren Island children more opportunities to leave the island for recreation. In April 1921, at Shaw's request, Brooklyn Park commissioner John N. Harman arranged for 150 children "who have never seen a tree or flower and hardly a blade of grass" to visit Prospect Park for boat rides, carousels, a visit to the zoo and a picnic. According to reports in the *Eagle* and the *Evening World*, the trip was a great success.[185] "The children's delight was evidenced in shouts and squeals of delight when the herd of sheep [that grazed in the park] was brought to them to be played with," reported the *Evening World*. Both newspapers made special note of the children's enjoyment of fresh milk, as they were used to drinking canned condensed milk at home. Just a couple of weeks later, twenty-five Barren Island children were taken to the circus—sponsored by the *Eagle* and Barnum & Bailey. Not surprisingly, given its sponsorship, the *Eagle* found this experiment to be a success as well: "the children had one round after another of genuine enjoyment." The reporter was impressed by the children's respectful response to seeing the American flag in the circus parade: "without a word from their teachers, hats were lifted and all rose to their feet."[186]

Recreation was an aspect of Barren Islanders' daily lives that was fully apart from work, providing meaning and enjoyment to residents. Most recreational activities were initiated and carried out independently by the islanders. Another arena of life for many islanders, separate from work, was religious observance. In contrast to recreation, opportunities to formally worship were not under the control of islanders. The Catholic church, Sacred Heart (originally St. Andrew's)—which opened in 1900, had a resident pastor from 1908 to 1914 and continued to hold services until 1942—had a consistent following. The nondenominational Protestant church was created by a self-styled "missionary" and lasted only from about 1900 to 1917. Although there are occasional references to Jews living on Barren Island, there is no available evidence hinting at any organized Jewish observance or clergymen on the island.

Both the Catholic and Protestant churches were established in 1900. The year before that, a Miss Mattie Smith, from Brooklyn, began holding twice-weekly nondenominational Protestant services in the now-abandoned first schoolhouse. Smith was determined but not always rewarded for her efforts: "She has met with discouragements in many cases from those she has tried

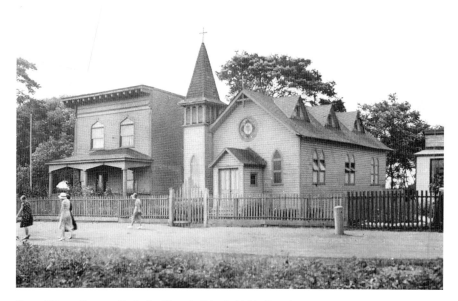

Sacred Heart Roman Catholic Church, July 5, 1931. *Photo by Percy Loomis Sperr. Brian Merlis collection.*

to help, but most of the women have aided her in every way possible."[187] Later that summer, Charles Peto, the one man on the excursion to Rockaway Beach mentioned earlier, told an *Eagle* reporter, "Before Miss Smith came the men had no place but the saloons to go to evenings. Now a good many of them go to the Thursday and Sunday evening services; consequently few get drunk and troublesome. Anybody can see that."[188] Peto's comment was unusual in that the connection he made between churchgoing and morality was much more often raised by outsiders than by residents.

In June 1900, the Catholic church opened, and the *New-York Tribune* editorialized that this would "mark a new advance in the elevation of Barren Island."[189] The church was financed by Mr. and Mrs. Thomas F. White of the garbage factory and donated to the diocese. The following month, the new Protestant chapel, built "mainly through the earnest efforts of Miss M.E. Smith," was dedicated.[190] According to reports in the *Eagle*, many Brooklynites came to Barren Island for the dedication and "all [were] convinced that this was a missionary field that ought by all means to be cultivated."[191] The idea that Barren Island would make a good site for missionary work is a revealing example of the common outsider notion that its residents were living in an unredeemed state of nature. It also reinforces the sense of Barren Island as a remote location.

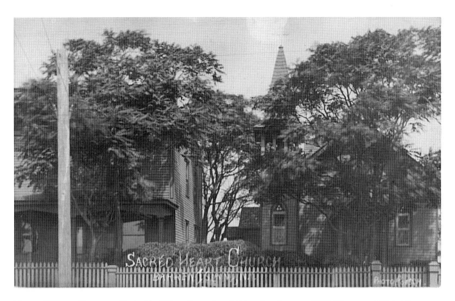

Sacred Heart Roman Catholic Church and neighboring house. *NPS/Gateway NRA Museum Collection, catalogue number 19662.*

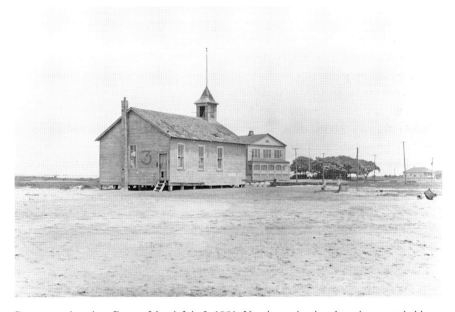

Protestant chapel on Barren Island, July 5, 1931. Nondenominational services were held in the chapel from about 1900 to 1917. *Courtesy of the Queens Borough Public Library, Archives, Eugene L. Armbruster Photographs.*

Regular services apparently continued in both churches, presided over by clergymen from off the island, for the next eight years. In 1908, an important change happened at Sacred Heart, with the assignment of its first resident pastor, Reverend Bronislaus Malinowski. A native of Poland, the twenty-five-year-old Malinowski also spoke fluent Italian. According to the *Brooklyn Eagle*, "the arrival of the priest was a gala event for the Polish Catholics," with singing, a brass band and children strewing flowers in his path. Father Malinowski gave a sermon and celebrated Mass, and the *Eagle* predicted that the island would soon host "a school presided over by Polish sisters."[192]

Father Bronislaus Malinowski, resident priest at Sacred Heart Roman Catholic Church from 1908 to 1913. *Courtesy of Diocese of Brooklyn Archives.*

The school never materialized, but Father Malinowski stayed in his post for five years and presided over dozens of weddings and baptisms, as well as regular church services. Meanwhile, all was not well at the Protestant chapel. Another article at the time of Malinowski's installation reported that "there has been some trouble at this [Protestant] church lately, and it has been locked."[193] The few reports about the church after this point do not mention Miss Smith, and the church never had a resident pastor. In 1922, its building was foreclosed on, and the *Eagle* reported that services had ceased five years earlier.[194]

Following Malinowski's departure in 1913, Father Charles Schimmel was assigned to Sacred Heart, and he stayed for a year.[195] After he left in 1914, the church was never again assigned a resident pastor; diocesan records do not indicate the reason for this. The church itself stayed open until 1942, with priests from St. John's Cantius Church in East New York serving first Barren Islanders and then

Father Charles Schimmel, resident priest at Sacred Heart Roman Catholic Church from 1913 to 1914. *Courtesy of Diocese of Brooklyn Archives.*

members of the U.S. Naval Air Command after
in the 1930s.[196]

While Barren Islanders had a lot of control o
recreation and created their own fun with only occasic
the opposite was the case when it came to formal relig
did not have the means to create houses of worship or
If not for the donation of the church building by the Whi unlikely
that there would have been a Catholic church on the isla. . The Protestant
chapel, likewise, was erected with the financial assistance of "missionaries."
It is hard to know how important the existence of these churches felt to
islanders. Regardless of that, one thing is clear: Barren Islanders were not
in a position to determine what religious facilities would be established on
the island. When it came to two fundamental aspects of life on the island
apart from work, they were quite proactive and creative in their approach to
recreation, while in the case of religion, the islanders appear to have been
much more passive, accepting the help and decisions of outsiders. Perhaps
this is simply because formal religious observance requires a congregation
and a clergyman, while recreational activities often require little in the way
of organization or expense.

MUNICIPAL NEGLECT

These people pay the same rate of taxes, but in spite of the important service they perform they are neglected almost entirely in the matter of returns for their money. There is no protection from fire, and there is slight provision for water. Some time ago the health authorities discovered that the wells were impure, and they were condemned. Of course, they were impure, but when they destroyed them there should have been some provision made for providing pure water.
—*"A prominent worker" quoted in the* Brooklyn Daily Eagle, *November 10, 1912*

$4,000,000 for an airport and not even $6,000 to give Barren Island a water supply and good roads.
—*Jane Shaw, quoted in the* Brooklyn Daily Eagle, *September 8, 1931*

Barren Island was first part of the Town of Flatlands (one of Brooklyn's original six towns), then briefly (1896–98) of the City of Brooklyn. Finally, after the consolidation of the five boroughs in 1898, it became part of New York City itself. All of these municipal entities frequently neglected the island's need for public services. Two important public services, law enforcement and education, are the subjects of the next two chapters. The current chapter focuses on other services, especially firefighting and water supply. In both cases, islanders were left largely to their own devices. Though the island was, of course, surrounded by water, this resource was largely useless for firefighting, because there was no water pressure for hoses,

and it was also useless for drinking, because it was salt water. As a result of this neglect, Barren Islanders fought their own fires and dug their own wells. They also got by without roads, bridges and emergency medical services— sometimes providing their own version of these services and sometimes simply doing without. Much like pioneers venturing west around the same time, Barren Islanders fended for themselves—the difference being that they did so while living in the largest city in the United States.

The history of firefighting on Barren Island reveals a mostly unchanging decades-long pattern in which fires broke out, mostly in the factories, and were fought by hastily organized bucket brigades. In Brooklyn and New York City during this time, according to the New York City Fire Museum, firefighting practices changed dramatically—for example, steam-powered pumps and motorized wagons were introduced—but Barren Islanders continued to fight fires using the same primitive buckets that the earliest Dutch settlers had employed three centuries in the past.[197] Brooklyn and New York began to acquire fireboats starting in the 1860s, and these were sometimes called to the scene of Barren Island fires, but they almost invariably arrived too late to make any difference. As the *Brooklyn Daily Eagle* put it after a 1906 fire, "Barren Island is a long way from anywhere," so without adequate fire protection on the island itself, fireboats and firefighters from off the island would do little good.[198] A fire burning out of control on this small island could be absolutely terrifying to residents, who sometimes jumped into boats and set out to sea, while people in nearby coastal communities could only watch helplessly.

Barren Island factories used a number of devices to heat garbage and dead animals to the boiling point and beyond. We have seen already in chapter 4 that this could cause serious scalding injury to workers. It also created a fire hazard, especially since many of the buildings were made of wood. When fire broke out, the isolation of the island came into sharp focus. The first reported factory fire occurred in March 1892. The *Evening World* related the story told by a man "too excited to give an intelligent account" but who was able to state that P. White's fertilizer factory had burned to the ground, that "the only two telephones on the island were burned also, and all communication by wire with the isolated spot is cut off."[199] The *Sun* reported about the same fire that "all the workmen on the island turned out to fight the fire, but their efforts were fruitless."[200] This would become a consistent refrain over the years. Though islanders worked quickly and collaboratively to fight fires, they simply did not have the equipment to make much of a dent in anything but the smallest fires. To make matters worse,

there was "practically no insurance...inasmuch as companies do not care to take risks in a place where the protection against fire is so small as on Barren Island."[201] The elements present in this earliest reported fire were repeated numerous times in the subsequent decades, even as firefighting responses improved significantly in other parts of New York City.

Although most reported fires took place in factories, there were occasional tragedies in residents' homes. In March 1906, a five-year-old boy, Felix Cawano Jr., apparently started a fire with matches when his mother briefly left the house. "As soon as flames were seen issuing from [the house], every employee of the Sanitary Utilization Company, the chief industry on the island, rushed to the scene and formed a bucket brigade."[202] Felix died in the fire, and both his house and that of a neighbor were significantly damaged. Of course, there is no way to know what the outcome would have been if better firefighting capacity had existed on the island, but it is certain that a bucket brigade is much less effective than sufficient hoses with sufficient pressure.

The next major fire on Barren Island, on May 20, 1906, came at a time when the island's population had grown and the factories were handling more garbage. The New York Sanitary Utilization Company's plant was completely destroyed, and the loss was reported as at least $1 million. The city took a bit more notice this time, since it would now have no option but to dump garbage at sea until the plant was rebuilt. (The animal rendering plant was not affected by the fire.) The local newspapers reported on this fire and its aftermath in several quite lengthy and prominently placed articles. As the *Eagle* observed, "The flames spread with great rapidity, for there was a brisk wind blowing....The handicap was the lack of facilities for putting out the fires." By this time, the big factories had some internal capacity for firefighting, but it was usually inadequate. In this case, the Utilization Company's "fire extinguishing plant...was soon rendered useless by the flames reaching the power house. Then the neighboring factories lent their firehose and pumps and men but they were powerless to prevent the spread of the flame."[203] The *New-York Tribune* pointed out that "the water supply seemed to be sufficient, but there was a want of pressure."[204] The local police substation summoned its commander from Canarsie, who in turn called for a fireboat, but by the time it arrived, "it was plain that the entire plant of the utilization company was doomed, and the most the firemen could do was to prevent the spread of the flame to the White Company's place, dangerously near by. It is indeed a wonder that it was saved at all."[205] The fireboat was not only slow but also "had

never been at Barren Island before, and had to find a skilled pilot before attempting to enter Rockaway Inlet."[206]

Local residents were reported to be extremely frightened by this fire. No wonder, when there was an "explosion of twelve hundred barrels of oil, followed by the big, lurid flames which rose into the sky."[207] Barren Island's small size made the prospect of a spreading fire very scary. According to the *Tribune*, "several Polish laborers, maddened by the thought that they could not escape from the island, threw themselves into the bay" and had to be rescued by boatmen. The newspaper made repeated references to the ethnic background of the laborers, perhaps implying that native-born Americans would not have reacted with such panic. Until the oil explosion, "the foreigners employed on the island were kept together," but afterward they simply fell apart with fear. The *New York Times* also reported on the attempts of many "Polish, Bohemian, and Italian" islanders to escape, including one woman who fell into the bay and was "scolded…in Bohemian" by her husband for losing their pet parrot and marble clock.[208] The patronizing tone of this report is telling, and it is consistent with other remarks about the immigrant population.

For months afterward, New York City garbage was taken twenty miles out to sea and dumped, with the hope that it would not wash back up on bathing beaches in New York and New Jersey. Many who had hoped to shut down the garbage plants anyway, because of the smell, saw an opportunity and tried to prevent the reconstruction of the plant, suggesting that the island could instead be better used for a hospital or a park.[209] However, no one came up with an adequate alternative to processing garbage on Barren Island, and the Sanitary Utilization Company was rebuilt—only to suffer *another* fire on May 12, 1907. Though this one was less damaging, at only a $50,000 loss, the *New York Times* reported that, once again, "the work of disposing of the city's refuse will be interrupted for an indefinite time."[210] Even when the city's ability to deal with its garbage was repeatedly disrupted, the political will did not seem to exist to improve firefighting capabilities on Barren Island, and its residents—ridiculed as hysterical foreigners—lacked the influence to affect change.

More fires broke out in the coming years, with very similar responses and results. Though newer buildings were made of concrete, much of the material being processed on the island was quite flammable. When the New York Sanitary Fertilizing Company's storage shop caught fire in March 1908, it was full of tankage—dried animal residue used for fertilizer. As usual, "night workers on the island formed bucket brigades, but the fire soon

got away from them and it was getting away from the firemen when more engines arrived in answer to a second alarm."[211] Three years later, at 8:00 p.m. on March 24, 1911, a residential house caught fire, "presumably by the overturning of a lamp. Within a few minutes the flames had jumped to a dozen other two story houses and they were completely destroyed." The usual bucket brigade was started up, joined by Canarsie police who had come by boat, "but the wind was too heavy to make their efforts good for much. A fireboat started from the Battery, but hadn't reached the island at 3 o'clock"—five hours after the fire broke out.[212]

Several fires in 1916 and 1917, like the one in 1906, incapacitated the garbage plants and again forced the city to find other ways to dispose of garbage (mainly sea dumping). A May 1916 fire had a painfully slow response. A police boat patrol noticed a fire at the White Company reduction plant. A patrolman woke up the only policeman on Barren Island and telephoned headquarters for assistance. The factories once again fought the blaze unsuccessfully with their own inadequate firefighting equipment. A fireboat arrived three hours later, "too late to do anything but throw water on the ruins."[213] Three months later, a fire started in a saloon or hotel and began to spread. A bucket brigade was organized, and a fireboat was sent for, but hours later, "the fire was still resisting the efforts of such fire fighting force as could be gathered, the flames lighting the heavens so the glare was visible over many parts of Brooklyn."[214]

Just a few weeks after that, an enormous fire destroyed ten buildings of one of the animal rendering plants. Just as in so many other fires, alarms were sounded, locals did their best to fight the flames and fireboats arrived too late: "the flames had gained such headway that it was impossible to save the plant."[215] The fire was "still burning briskly" a day later. Phone service was out, as were the pumping station and electric power plant. "The fire boat William L. Strong was playing water on the ruins late last night," reported the *Sun*, demonstrating the futility of relying on fireboats in this location "a long way from anywhere."[216]

Although the burned garbage plants were rebuilt, the city was already looking for alternatives and had built a small plant on Staten Island. In 1919, garbage processing ceased on Barren Island altogether, though animal rendering continued. The garbage plant buildings remained and continued to constitute a fire hazard. One of the abandoned "immense wooden" buildings burned in 1921. It was "surrounded by shacks in which live some 20 families, and it required herculean efforts on the part of an impromptu bucket brigade to save these from destruction. There was no

water power available on the island and the fire boat, Mayor Gaynor, the only apparatus which went to the scene, was able to do but little to check the flames."[217] Clearly, the abandoned buildings should have been demolished in order to prevent such disasters.

With the arrival of Jane Shaw as school principal in 1918, the newspapers' responses to the fires changed noticeably. Shaw's advocacy on behalf of the islanders, described in more detail in chapter 8, focused in part on forcefully defending their full humanity and their efforts on their own behalf. This had a conspicuous effect. In the past, islanders had been portrayed as hapless victims of fires, unable to respond adequately, perhaps because of their inferior status as immigrants and African Americans. As just mentioned, in the 1921 reporting, locals were referred to as making "herculean efforts," rather than dismissed as panicking foreigners. Similarly, after a 1922 residential fire fought by teachers, janitors, pupils and others, the *Eagle* reported, "It was only by [their] heroic efforts…that one side of the island was not laid in ruins."[218] More fires in 1922 again highlighted the pointlessness of summoning the fireboat, which each time "arrived too late."[219] At the end of that year, the school custodian, Noah Decker, who like Shaw had become a vocal advocate for the islanders after being randomly assigned to the school, began to make a concerted effort to obtain better fire equipment for the island. He invited the fire commissioner to the island, organized a volunteer firefighting company and demanded longer, stronger hoses and other equipment. He pointed out that the volunteers should be "entitled to some of the 2 percent tax which the foreign insurance companies had to pay to the State, and is now to be distributed to volunteer companies."[220]

It appears that hoses were supplied, but better hoses could not compensate for the lack of water pressure. A 1924 fire at the rendering factory demonstrated both this fact and the changed perspective of outsiders toward Barren Islanders' firefighting fortitude:

> *The half hundred young men whose pride it is to form the local volunteer fire corps, bounded from their beds almost as one man. Struggling into their clothes as they ran toward the blaze that made the surrounding blackness all the more dreadful, they had their hoses attached to the hydrants before the dangerous flames could gain any great headway. To their dismay, they found themselves badly handicapped in their work by the feebleness of the water pressure at their command. But the fire fighters of Barren Island, refusing to be daunted by mere lack of water pressure, supplemented their hose with*

bucket brigades so effectively that, after an exciting hour or so of hard work, they were able to go back to their beds with the prideful knowledge that they had once more saved their own homes.[221]

Now, instead of disorganized victims who were at the mercy of their fate, Barren Islanders were portrayed as noble fighters overcoming daunting obstacles in their fearless battle to save their community.

The problem of firefighting on Barren Island was never really solved. In 1931, Shaw was still pointing out the lack of fire protection or insurance to anyone who would listen.[222] By this point, Floyd Bennett Field was in full swing as an airport, and the residents likely realized that they wouldn't be living there for much longer as a result. Over the years of municipal neglect, they had perhaps been lucky that the numerous fires had not dealt them a much higher death toll. But more than luck was responsible for this; it was really the persistence of the islanders in repeatedly fighting flames with almost no help from off the island. Barren Islanders took care of themselves.

The provision of water to Barren Islanders was another ongoing issue, one which none of the governing municipalities fully resolved. As shown above, the availability of limitless amounts of bay water was not sufficient for firefighting, since there was little or no pressure to propel water through hoses with enough force to fight fires. This same abundant water was useless for drinking, since it was ocean water. Though there are fewer historical sources relating to water supply than to firefighting on the island, it is clear that islanders did not have a consistent supply of safe drinking water, and that what they did have, they often had to obtain themselves, without municipal help.

It is unclear how Barren Islanders got water in the first fifty or so years of the island's modern history (the second half of the nineteenth century). Presumably, they collected rainwater and dug wells. It is also likely that workers dug wells for the factories' water needs. In a 1901 article that focused on citywide corruption in the water supply, an official from the New York City Department of Water Supply was quoted as saying, "The Health Board has had the nerve to ask us to supply water to a new school on Barren Island, when the city has no water pipes on that island."[223] It is therefore evident that islanders were continuing to provide their own water without municipal help. In 1908, the *Eagle* reported that "on Barren Island wells similar to the Seaford wells have been in use for years and have supplied the water for the population of the island, as well as the large manufacturing and garbage utilization plants on the island." (Seaford, Long Island, had "what is believed

to be an inexhaustible supply of the purest crystal water from a vast bed of clean white Lloyd gravel about 800 feet underground.")[224]

This optimistic 1908 report, however, was contradicted by an article in the same newspaper the following year, which stated that there was one well that "belongs to the fertilizer manufacturing company."[225] This report focused on the needs of the six teachers on the island, as well as their hundreds of students, who had no access to well water and had to resort to collecting rainwater in a barrel. It is unclear whether households had access to the well water mentioned or had to collect rainwater as well. Meanwhile, most of the rest of New York City had an adequate supply of safe drinking water, piped in from upstate through the Croton Aqueduct, beginning in 1842.[226] The article or some other pressure seemed to have had an effect: On November 30, 1909, a classified ad in the *Eagle* sought bids "for driving well at Public School 120, Barren Island."[227]

A few years later, as a result, matters had changed slightly. A "prominent worker," interviewed by the *Eagle*, reported that "until two years ago it was almost impossible for the people to get water. The school teachers had to use rain water, and often a whole family had to limit itself to a pint a day. Now, to be sure, there is a new 700-foot well at the schoolhouse, but that does not solve the problem. This well wastes water, which runs off into the meadow, when there should be some way of piping it to the rest of the island, so that people wouldn't have to come all the way to the school to get water."[228] This suggestion was not followed up on. In 1915, the *Sun* reported that New York

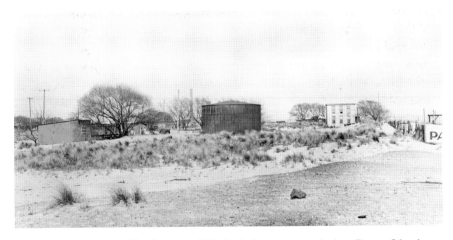

Water tower on Barren Island, north of Flatbush Avenue, near the bay. Barren Island was never connected to the water system of any municipality, and residents had to collect rainwater and dig their own wells. April 21, 1931. *Photo by Percy Loomis Sperr. Lee A. Rosenzweig collection.*

State Health Department staff had learned that "a large proportion of the people were drinking water from surface wells" that were not sanitary.[229] The city apparently did nothing; Jane Shaw told the *Eagle* in 1930 that Barren Islanders got their water from wells "which we've built ourselves."[230] This was still the status quo in 1931.[231]

Though newspapers reported much less about water than about fire—perhaps because the collection of rainwater is less dramatically engaging than flames leaping through the sky—the same pattern is clearly evident in both cases. Municipal governments did not make provision for a water supply on Barren Island. The factories did some well-drilling to satisfy their own needs. People got by with rainwater they collected themselves and wells they dug themselves. Occasionally, a bit of interest was shown by the city, as when it paid for the digging of a well at the school. But for the most part, as with firefighting, Barren Islanders were on their own when it came to meeting their own need for water. They did what needed to be done; if they complained, no record of their grievances remains.

In addition to firefighting and water supply (as well as law enforcement and education, discussed in the next two chapters), Barren Islanders had various other needs that were generally neglected by municipal governments. With little information available, it is unclear how and when the island was provided with telegraph, telephone or electricity services, although William Maier remembered that in the 1920s there was only electricity in the school, the teachers' cottage and the janitor's cottage (and presumably in the horse factory, the only one remaining at that time). In contrast, much of New York had gotten access to electricity around the turn of the century.[232] As the *Sun* put it half-jokingly in 1915, "For years on years the islanders had peacefully pursued their simple life, undisturbed by any prying of official eyes....Great and wonderful improvement in welfare movements had taken place in the various boroughs. But the Barren Islanders had not been bothered at all."[233]

There are a few pieces of evidence regarding other services, how they were or weren't provided and how Barren Islanders responded. In 1897, "There came to the mayor this morning a petition from manufacturers and residents of Barren Island asking for the construction of a foot bridge across the creek [Deep Creek] and marsh which divide the island into two parts."[234] This petition does not seem to have survived in the records, and it is unknown whether a bridge was built as a result of it. (A bridge was definitely built at some point, remembered by former residents Josephine Smizaski and William Maier as the "horse bridge," because you could drive a horse and wagon over it, and also identified at times as Long Bridge.) Interestingly,

The Long Bridge over Deep Creek on Barren Island, April 21, 1931. *Photo by Percy Loomis Sperr. Brian Merlis collection.*

the same article about the bridge notes that in their petition, residents "call attention to the fact that the assessment estimate of the island is between $4,000,000 and $5,000,000 and to the further fact that notwithstanding this, the city has never expended a dollar for public improvements there." Clearly, at least some of these supposedly untutored and ignorant foreigners were well aware of the inequity in their living situation.

Fifteen years later, the "prominent worker" interviewed by the *Eagle* remarked:

> *There are only a few lights and none in the west end, as there should be. Another crying need is for an emergency hospital. There are a large number of accidents and cases that need quick attention. It may be three hours and it may be six before an injured person can be taken to the city, and the boats are not adequate for such a purpose. It wouldn't cost the city over $3,000 to erect such a hospital and equip it with a couple of wards and an operating room, with a physician and nurses in charge.*[235]

The hospital was never built. Physicians did visit the island regularly, but this, of course, depended on whether the ferry was running. In bad weather, they could not come. As a result, when Jane Shaw began living on the island during the work week (and eventually year-round), she "got in touch with a

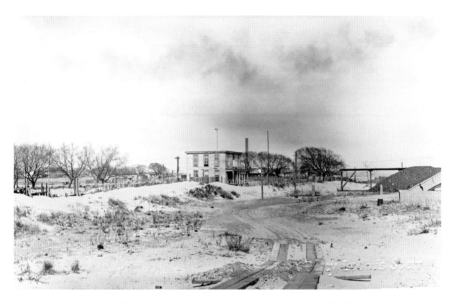

Barren Island, north of Flatbush Avenue, near the bay, April 21, 1931. The plank road seen here typified Barren Island streets, which were not paved. *Photo by Percy Loomis Sperr. Lee A. Rosenzweig collection.*

physician on a naval transport anchored off Rockaway Beach, took some first-aid lessons from him, learned the symptoms of the most common diseases and, with his assistance, acted as doctor to the colony for years."[236] Shaw also pointed out that when the city declined to do so, residents built their own plank road from the Flatbush Avenue extension into the village; that the United States "ignored [the island] in the [1930] census"—until she intervened; and that New York State "denies the protection of State game laws to its birds and fowl, which are openly killed by Sunday visitors."[237]

"The island…is city-owned and city-neglected.…It is a community neglected by country, State and city."[238] This observation is proved by a close look at the history of firefighting and water supply on Barren Island and further buttressed by glimpses of other public services, or the lack thereof. Islanders faced unavoidable challenges when it came to these services. They had no choice but to fight fires as well as they could with the woefully inadequate supplies on hand, and they rose to the occasion as well as possible with each of the many fires on record. Similarly, they provided for their own water needs through collecting rainwater and drilling wells, with little assistance from outsiders. While performing vital services themselves, Barren Islanders were denied equally vital services from the city that was their home.

6

LAW AND ORDER

Two men were badly wounded as the result of a shooting following a quarrel over a game of pool in a saloon on Barren Island last night.
—Brooklyn Daily Eagle, *September 29, 1902*

[Bartender Stephen Gustne] *stated that he did not do anything wrong. He said he simply sold liquor to a woman last Sunday. The fact that a law had been violated was as foreign to his mind as anything could be. "Nobody is arrested at Barren Island for that," he said.*
—Brooklyn Daily Eagle, *March 31, 1909*

The island today, according to Miss Shaw, is the most moral spot in New York City. People never lock their doors, nor is there ever the slightest jeopardy to life or limb.
—Brooklyn Daily Eagle, *June 22, 1930*

Like other municipal services, law enforcement was often scant on Barren Island, although the city did pay more attention to policing than to firefighting, water supply or infrastructure. Some criminal activity on the island was similar to that elsewhere in the city; for example, there are countless reports of bar brawls in the pre-Prohibition days. Other law enforcement issues were more unusual and resulted from the isolated location and the industries present on the island. For instance, garbage plant employees would sometimes steal and re-sell hotel silverware that had been accidentally discarded and was supposed to be returned to its owner. There

eged criminals who escaped from law enforcement by
aes or jumping into boats and rowing away—an option
ost New York City suspects. When it came to bringing
ce, for much of the island's history, policing was done in
shi... rs sent from neighboring Canarsie, usually just one or two
at a time, a.. not at all hours of the day. In 1897, a police substation was
established on the island with a more consistent force present—still coming
in shifts from Canarsie—but reinforcements still had to be called in on the
rare occasions that a more serious event took place. One resident policeman,
the reportedly revered William Evans, lived on the island from 1911 until at
least 1918; his wife acted as a sort of unofficial assistant officer. Witnesses
and people charged with crimes would have to be taken by boat to Brooklyn
to go to court, often needing to leave the night before in order to be sure of
making it to court on time for morning appearances.

No criminal activity was publicly reported in the early years of the island.
A review of newspaper reports of law enforcement issues from the 1870s
to the 1930s reveals a mostly peaceful community, with a modest share of
low-level criminal activity, mostly fights. There seems to have been little
property crime in the residential community itself, and several residents and

The old Sixty-Sixth Precinct house located on the north side of Glenwood Road between
East Ninety-Fourth and East Ninety-Fifth Streets in Canarsie, circa 1907. Police officers
from Canarsie were dispatched to Barren Island by boat in shifts and as needed. *Brian
Merlis collection.*

newspaper reporters noted that residents kept their doors unlocked. A small-scale violent fight in 1883 illustrates the typical pattern: twenty-six-year-old Samuel Mahon hit his fellow workman, Patrick Conway, with a beer glass, causing Conway serious injury. "Mahon escaped but was followed to the city by the Flatland police and finally overtaken last night."[239] Although the location of this fight was not specified, the use of a beer glass suggests it may have been at a saloon; saloons were very often the site of these altercations. Some also occurred at boardinghouses, such as a fight in 1884, in which a fish factory worker named George Nagengast "quarreled at the dinner table in the boarding house of Mrs. Berghard on the island. Nagengast was under the influence of liquor and was very offensive in his language." He proceeded to stab his coworker Felix McNeely in the neck with a table knife.[240]

These fights are representative of many that occurred in the decades before Prohibition was enacted in 1920. Common elements of such fights included the consumption of alcohol, brief verbal arguments, gambling disputes and the use of weapons that came easily to hand, like table knives, beer glasses and fists. Now and then, a small group of men would gang up on another, as in an 1885 case in which Michael Hooley (or Cooley, depending on the article) was beaten to death by a group of four or five other men after an argument about a card game at a saloon.[241] It was sometimes difficult for the judicial system to respond adequately to these incidents. In the case of Hooley or Cooley, a coroner's inquest delivered the verdict that he had been murdered by these five men ("a crowd of roughs" according to the *Eagle*[242]), but a doctor who testified at the inquest had left town by the time of the trial, and the men were released.[243]

Other such fights occurred over the years, most resulting in injuries but not death. Fights that involved women were often reported in more detail by the press. For example, in 1902, "Mrs. Mary Schmidt, a Pole, thin, and with a face that denoted both labor and privation" and "Mrs. Annie Doll, a German, fat and 40, the wife of the local grocer, butcher, baker, etc., whose countenance was of that broadness and rosiness which always denotes good cheer," appeared in the Flatbush court.[244] They had gotten into a verbal dispute, the subject of which was not mentioned, which quickly developed into punching, hair pulling and throwing objects at each other. By the time they appeared in court, neither apparently had any visible injuries. The *Brooklyn Daily Eagle* recounted some of the testimony verbatim, in an article considerably longer than most of those that reported on more serious men's fights, even though Schmidt and Doll seem to have done each other little harm. A fight between Mary Polsoska

The Empire Hotel on Barren Island, north of Flatbush Avenue and west of Board Road, March 1929. *Brian Merlis collection.*

and Mary Mischifowitz in 1910, in which the latter threw either nitric acid or boiling water at the former, was also given a more thorough report by the *Brooklyn Daily Eagle* than most men's fights.[245]

Although occasional robberies were reported, such as the case of Antonio Sayboa, who was robbed of $235 while sleeping in a boardinghouse in 1909, these were quite rare, and by far the most common criminal complaint continued to be alcohol-fueled brawls among men.[246] Very often these led to appearances before magistrates in Brooklyn courts, though newspapers usually did not report on the ultimate sentencing. One article claimed that there was actually a season for Barren Island fights: "The spring fights have begun on Barren Island. The climate there is invigorating, and when spring comes a certain element of the population feels so strong it wants to fight."[247] The dates of reported fights over the years, however, do not support this imaginative hypothesis.

What did make a difference in the timing of Barren Island fights was Prohibition, which began in 1920. The slow but steady stream of reports about fights came to a complete halt after 1917. No crimes were reported by local newspapers after the start of Prohibition until 1929 and very few after that until the islanders were evicted in 1936. People who lived on the island at this time also reported a sense of peace and safety. Josephine Smizaski recalled in an interview that she "never heard of any" crime. "No stealing, no nothing. Your doors were wide open." William Maier, who lived on the

island from 1917 to 1935, remembered no crime except a bit of bootlegging for personal use. In fact, his mother made beer for his father and his friends, which they kept in the family cellar. Maier also suspected that "a lot of Polish people were making whiskey," but on a small scale. Jane Shaw moved to the island to work at the school in 1918 and told an *Eagle* reporter in 1930 that "people never lock their doors, nor is there ever the slightest jeopardy to life or limb. A policeman goes there every day, but there has been only one arrest of an islander in the past 12 years. That was for a traffic violation."[248]

Shaw, advocating for more services for islanders, had an incentive to perhaps exaggerate the extremity of the residents' law-abiding nature. It is unlikely they were more saintly than other New Yorkers, and at times they turned the isolation of their home to their advantage when it came to both committing crimes and evading responsibility for them. At times, a crime might be ordinary but the law enforcement response was unusual because of the island's remoteness. For example, in 1902, "two men were badly wounded as the result of a shooting following a quarrel over a game of pool in a saloon on Barren Island."[249] This crime, quite typical for Barren Island at the time, led to a call to police headquarters in Canarsie, because there was only one policeman on the island at the time. The captain in Canarsie dispatched two more officers, but it took them a long time to get there. "There is no way of reaching the island at this season of the year except by rowboat, and after a long and exhausting pull across the bay in a blinding mist against a strong tide, the police reinforcements arrived at the scene of the trouble." Luckily for the injured men, they apparently survived and were brought to a hospital in Brooklyn. In 1910, after yet another barroom fight, George Jones shot and killed Henry Holly. Jones hid in the marshes and then in a boat before being caught by Policeman Isaac van Houten.[250] While Jones was caught and later sentenced to prison, other perpetrators managed to escape the island by boat, including some Italians who participated in a "riot" in 1871 and another Italian who shot three people in 1917 and then "escaped from Barren Island in a rowboat."[251] In 1918, just at the end of World War I, a German shot and killed a Barren Islander with whom he had been arguing about the war. "The German fled to the marshes of the island and it is believed escaped by boat."[252]

Yet another Italian, Joseph Yottabush, exemplified a different problem that the island sometimes presented to law enforcement, which was the difficulty of bringing prisoners to court in Brooklyn after they had been arrested. Yottabush was charged with felonious assault in January 1912, during a cold spell. The bay was iced over, and Policeman Evans had no

Flatbush Town Hall, 35 Snyder Avenue, 1875. People arrested on Barren Island would be brought to court in this building. *Photo by George Bradford Brainerd. Brian Merlis collection.*

way to bring his prisoner to court. According to the *Eagle*, "up to a late hour today the police were raptly studying charts and maps to devise ways and means to bring their prisoner to justice....Clerks in the Flatbush court were also assiduously engaged today in trying to discover whether there was any statute of limitations that would interfere before the prisoner can be arraigned."[253]

In addition to these more ordinary crimes, Barren Island was also the site of opportunistic crimes that were dependent on its remoteness. In the early 1870s, it was the home of a substantial illegal distillery. In 1873, tax assessors, on the lookout for liquor that was being sold without paying the requisite taxes being assessed, "destroyed an illicit still and several hundred gallons of mash on the eastern point of Barren Island."[254] Less than a year later, "one of the most successful and, at the same time, extensive seizures that have taken place in this vicinity for some time past, was effected." In that case, a still of one thousand gallons capacity, as well as "forty-five

barrels of whisky, fifty empty barrels, twenty hogsheads of molasses, fifty thousand gallons of mash, mash tubs, worms, pumps, and other minor implements"—and a "large schooner" used to transport these items—were seized by the authorities.[255]

As the island's population grew, it was no longer a practical place to run a large illicit still. However, several other nonviolent crimes over the coming decades also centered around liquor. An incident in 1909 demonstrated the sense of some islanders that their low-level crimes were not worth the authorities' bother. A bartender named Stephen Gustne was at work in Joseph Symont's saloon one Sunday when Policeman Isaac Van Houten "saw a woman open the front door of [the] saloon, enter, obtain a can of beer and depart." Since selling alcohol on Sunday was forbidden by law, Van Houten "told Gustne to dress up and go to the police station with him. The bartender was doubtful. He thought the policeman was jesting, and laughingly told him so." Van Houten insisted that he was serious and took the increasingly bewildered Gustne to the station house in Canarsie by boat. When he was arraigned the next day, Gustne continued to insist that a mistake must have been made. "He said he merely served beer on Sunday. He was indignant at the arrest. Who ever heard of a person being arrested for selling liquor at Barren Island before?" Indeed, according to court records, such an arrest had not been made for twelve years. It was quite clear from Gustne's confusion that liquor had been routinely served on Sundays ever since then. Following his arrest, the police were instructed to "keep an eye" on Barren Island saloons on Sundays.[256]

As with the illegal distilleries, much of authorities' concern over liquor law violations related to revenue taxes that went unpaid. In May 1909, a liquor salesman on the island, Anton Berger, was arrested by a collector from the Department of Internal Revenue for selling whiskey without paying tax.[257] "While out on bail he repeated the offense," and he was ultimately sentenced to a hefty $100 fine and thirty days in jail.[258] The beer and liquor production mentioned by William Maier during Prohibition appears to have taken place under the radar of the authorities until the very end; just months before repeal, "377 cases of alleged assorted liquors" were seized from a boat at the Barren Island ferry landing.[259] On the other hand, this was an operation on an entirely different scale from the home brewing that Maier mentioned, and its perpetrators may have only been using Barren Island as a transport way station.

A different type of crime of opportunity took place from time to time in the garbage factories. The White factory had an agreement with Manhattan

hotels and clubs to return silverware that had been accidentally discarded in their trash. (The silverware had its owner's name or monogram on it.) Some factory employees realized that they could simply withhold this silver and sell it to junk dealers. In 1905, such a scheme fell apart when Pincus Kaufman (or Kuffman or Kauffman, depending on the article) was arrested on the island with seventy-five dollars' worth of silverware and plateware that he had apparently purchased from factory employees.[260] This haul included 970 pieces with labels including those of "the Waldorf, St. Regis, Breslin, Manhattan, Algonquin, Ansonia, Netherlands, and the Fifth Avenue Hotels…[and] the New York Athletic Club and the Arts Club."[261] Judging by news reports, only Kaufman was arrested, and he did not give up the names of his associates who worked in the factories and supplied the silver.

A similar arrangement came to light a few years later, in 1911. Celia, or Delia, Golden (again, depending on the source) was arrested after police tracked to her Canarsie home "plated silver, forks, knives, spoons, etc., from almost every hotel in New York City."[262] As in the 1905 scheme, these materials came from the White garbage factory, and this time it represented a week's worth of silver retrieved from the garbage—"over 500 articles." Golden and a junk dealer named Louis Cohen were both charged with receiving stolen goods, and again, the thieves themselves appear to have gone uncaught and unpunished.[263]

A diverse array of other crimes over the years, though not connected to the factories on the island, were also dependent on its remote location. In 1898, a Barren Island pharmacist named Lazard Berlinger was charged with practicing medicine without a license. There was no doctor living on the island, and visiting a doctor in Brooklyn was a day's commitment, so it is not surprising that residents would be willing to do business with a conveniently located medical professional, even if he wasn't actually a doctor. However, when residents repeatedly found that Berlinger's recommendations were not helpful and even made matters worse, they were only too willing to testify against him. Anna Schrann stated that her ailment worsened after she followed Berlinger's advice, for which she was charged $4.85. Three others also testified that he had given them medical advice for which he was not qualified.[264] Although Berlinger's guilt seems clear from this testimony, the outcome of the case was not reported in the newspaper, and he was still working as a pharmacist on the island in 1902.[265] Barren Islanders were not in a position to be choosy about who provided them with medical services.

Some malefactors visited the island on purpose in order to commit crimes in a place where they would be more likely to elude capture. Even after the

construction of the Flatbush Avenue extension, such crimes were reported. In September 1930, a taxi driver named John Perrone drove a man named Charles May down Flatbush to a "lonely dune" on Barren Island. There, William J. Rose, who had been involved with May's estranged wife, shot May to death and was then assisted by Perrone in throwing the body into Jamaica Bay. Unbeknownst to Perrone, Rose then drowned himself. The sordid story emerged in bits and pieces over the next weeks.[266] Clearly, the out-of-the-way location was an important consideration to Rose as he selected a place to kill his rival.

More mundane illegal activities were also connected to Barren Island's location. In May 1930, two "special game protectors under the State Game Conservation Commission" were caught by another game protector hunting black duck out of season.[267] The following year, two Barren Island men were sentenced to a ten-dollar fine (converted to ten days in jail, since they were unable to pay) for taking half a bushel of clams from Jamaica Bay and selling them. This was illegal because "most of the creeks and canals in and around Long Island have been condemned as unfit for edible clams" due to pollution. Although it was legal to take up to a bushel of clams for personal use, selling them was not allowed.[268]

Even after Barren Islanders were evicted in June 1936, some of the few who remained as squatters were found to be engaging in a novel illegal enterprise: raising goats on a diet of "the narcotic marijuana weed." By all accounts, the goats' milk was quite normal. The crop was valued by the police at $500,000, and the squatters disavowed any knowledge of it. News reports did not mention any arrests, but Works Progress Administration (WPA) workers were instructed to uproot all of the plants.[269]

Apart from the illegal distilleries, which were dealt with by tax revenue agents, ordinary police from the Canarsie precinct handled most of the crime on Barren Island from the 1870s through the 1930s. In the early years, police patrolling of the island was sporadic. Then, in 1897, residents began to advocate for the need for more consistent policing. As a result of these complaints, Brooklyn police commissioner Leonard R. Welles and a Superintendent McKelvey made a visit to the island. According to the *Eagle*, "Mr. Welles knew very little of the place and the general impression at headquarters was that Barren Island was so isolated and really so unimportant that it did not need very much in the way of protection."[270] To Welles's surprise, the island turned out to be larger than he expected, and the committee of citizens and factory executives who joined him on his tour of inspection helped to convince him to pay it more attention. Welles decided

to establish a substation on the island with regular shifts of officers sent from the Canarsie station, as a result of which "in every respect the island will be like a miniature precinct, with all the modern police improvements." The substation was organized quickly, and beginning in June, four policemen shared the responsibility of patrolling the island.[271]

As already mentioned, the main duty of these officers turned out to be breaking up bar fights and bringing offenders to Brooklyn by boat for court appearances. Indeed, as the *Sun* reported two years later, the police "are looked upon as very big men indeed. There is not much for them to do, the islanders being law-abiding citizens, as a rule."[272] This was still the impression of reporters in 1904, when the *Eagle* reiterated this observation almost verbatim: "The island boasts of…a small but entirely adequate police force, for as a rule the inhabitants are a law abiding lot."[273]

However, a new police commissioner a few years later did not find the situation adequate. Rhinelander Waldo disapproved of the amount of time it took for officers to travel to and from the island. In 1911, "in despair over the loss of so much time, [he] asked for a volunteer policeman who would live permanently in the land of smells." William Evans offered his services, moved to the island and promptly married a local woman named Margaret and had a child. Islanders and his supervisors alike seemed satisfied with how Evans performed his rather light around-the-clock services. The *Evening World* reported in April 1912 that "for the last two months there hasn't been an arrest on the island. Up to that time there had been three arrests for felony and eight on misdemeanor charges."[274]

His marriage to a local came in handy for Policeman Evans. Soon after that report, on April 15, 1912, the *Sun* published a detailed article about a challenging situation that Margaret Evans resolved. A party among "the negroes who work for the Sanitary Utilization Company" had ended with a man named James Green suffering a fractured skull after a beating with a baseball bat. William Evans and additional police sent as backup could not manage to find out anything useful. Margaret then spent the day walking around Barren Island "interviewing negroes" until she was able to get a line on two suspects. She finally found where they were hiding, and they were arrested. The article made clear that Margaret's detective work was crucial to resolving this case. It is likely that her standing as a trusted longtime local resident may have contributed to islanders' willingness to share information with her that they would not reveal to her husband. A few years later, Margaret Evans was appointed a "police matron," a paid position, on Staten Island. While information

about her subsequent career is unavailable, she seems to have been a competent police officer in her own right.[275]

Margaret Evans was also involved in one of the several cases over the years that were misreported by local newspapers. Such overblown reports appeared occasionally, followed by corrections. In this particular case, later in 1912, a junk dealer charged that he had been beaten by four women on Barren Island who stole sixty-one dollars from him after he displayed a large roll of cash while buying two live chickens from one of them. While William Evans and reinforcements from Flatbush were able to easily arrest three of the women, the fourth, Mary Gashatsky, allegedly threw knives at the police and then fought with her feet and fists before the police were able to subdue her. As this was happening, according to both the *Evening World* and the *Eagle*, a crowd of hundreds of women (according to the *Evening World*) or men (according to the *Eagle*) surrounded the Evans home/police station while Margaret Evans held them off with her husband's gun.[276] In early November, the Evanses sat for an interview with the *Eagle* in which they corrected these reports, stating that "three or four women" had come to the house and that "Mrs. Evans took care of them."[277]

Barren Island, though perhaps not as purely crime-free as Jane Shaw declared, was overall a fairly orderly and safe community, judging by news reports and personal accounts. Though bar fights broke out frequently in the years before Prohibition, there was little other violent crime or crime against personal property. Residents appear to have felt comfortable leaving their doors unlocked, and after the police substation was established in 1897, they felt satisfied with the level of police protection. Some residents, to be sure, took advantage of the isolated location to engage in illegal behavior that might not have been possible elsewhere in New York City at the time, such as illicit alcohol manufacture or theft from the factories. The city was obligated to provide some level of law enforcement, which was generally minimal, and it appears that community norms were usually sufficient to keep the village orderly and safe. Reporters' tendency to remark on how law-abiding the residents were implies that this came as something of a surprise to outsiders, who perhaps expected that a mixed community of black and immigrant garbage workers would be a bit more rebellious against law and order. Instead, as in so many areas of their lives, Barren Islanders were able to function effectively, with little help from outside, in the arena of law enforcement.

7

EDUCATION

The school on Barren Island is a one and a half story frame structure that…is accessible at all times when the tide is not too high.
—Brooklyn Daily Eagle, *March 8, 1899*

Owing to the peculiar state of the island it will be very difficult under the most favorable conditions to secure teachers.
—Charles M. Chadwick of the Brooklyn Board of Education, *March 1899*

And we had the public school, which was a whole center of Barren Island. It was a community center, it was a school by Miss Jane F. Shaw, a real tiger, a wonderful person, a real educator, and she put all us people in line.
—William Maier, *former resident, recalling PS 120 in the 1920s and 1930s*

One aspect of municipal services that the authorities were legally obliged to provide was primary education. Because of geographical factors, it was clearly impossible to send the island's children to the mainland for school, though this was occasionally considered. A public school existed on Barren Island at least from the early 1880s until the eviction of the last residents—including about one hundred students—in 1936. Little is known about the early years of the school, when it would have been administered by the Town of Flatlands. During this period, the school consisted of one room located on the first floor of an ordinary house. Flatlands was annexed by Brooklyn in 1896 and then became part of New

York City when consolidation occurred in 1898. During this transitional period, the school and its single teacher/administrator fell into a severe but slow-moving crisis that the city ultimately could not ignore, culminating in the closure of the school and the erection of a more suitable building, which opened in 1901. From then on, the school functioned reliably, though there was great difficulty in retaining teachers, who had to live on the island during the school week. Student attendance was weak, and the school did not provide an eighth grade, making it quite difficult for attendees to continue on to high school. Though there is at least one report of children taking themselves by rowboat to Flatbush Avenue and then stagecoach to school in Brooklyn in the early twentieth century, this was clearly an exception to the norm.[278] It appears that islanders accepted this situation, or at least were unsure how to protest it, and many children born on the island grew up and took jobs or married there as adults, making a further education unnecessary.

This changed in 1918 with the arrival of the larger-than-life figure Jane F. Shaw, a veteran New York City public educator who was originally recruited as a one-year teacher-in-charge. After her first year, Shaw decided to stay and became a sort of fairy godmother to the islanders, helping to provide needed educational, recreational and municipal services to people of all ages.[279] The islanders were not passive recipients of her help but actively took advantage of her willingness to intercede on their behalf. They utilized her medical and counseling help, her advocacy relating to the provision of water, the movies and roller-skating rink she provided and the cooking and English lessons she gave to parents at night. And the children finally got to go to the eighth grade and could then continue on to Erasmus Hall or other high schools in Brooklyn proper—which was also facilitated by the extension of Flatbush Avenue to the island in the 1920s. Visitors to Barren Island in this period often commented on the impressive schoolwork of the children, and the school frequently topped the city's attendance charts. Toward the end of her career, Shaw spent several months teaching supine in her sitting room after suffering an inoperable injury at a school basketball game. Her last act on behalf of Barren Island was to demand that the famously bullheaded New York City parks commissioner, Robert Moses, delay the eviction from April 1936 to June so that students could finish the school year. Moses agreed.

The period during which Barren Island existed as a community coincided with a time in American history during which education for every child—and not just the elite—became more important and more common. In the second half of the 1800s, when the first families settled on the island, many American children got only a few years of formal schooling and were able

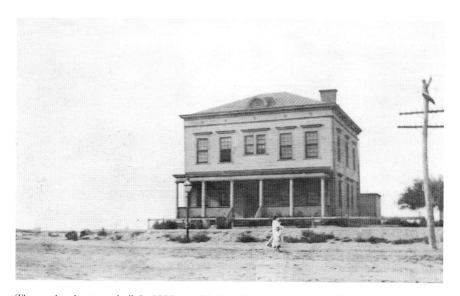

The teachers' cottage, built in 1900, provided housing for the school staff, who had to remain on the island Monday through Friday. Circa 1904. In 1935, Jane Shaw taught classes from her sitting room in this building after suffering a hip injury. *Lee A. Rosenzweig collection.*

to function perfectly well as working adults. Islanders did not need much book learning to work in the garbage, horse-rendering or fish-oil factories, to own a small retail business on the island or to run households as wives and mothers. A limited amount of education was quite normal for children in the United States in general: in 1870, only 2 percent of Americans had a secondary education, and only 48 percent of children from five to nineteen years old were enrolled in school. However, by the 1930s, when the island shut down, this had changed drastically. In 1940, 51 percent of American adults had a high school diploma, and 75 percent of those between five and nineteen years old were enrolled in school.[280] On Barren Island in the 1920s, it appears that all of the primary-school-aged children were enrolled, and attendance at PS 120 routinely exceeded 95 percent.[281] The changes in education on Barren Island, in terms of attendance, rigor and centrality to island life, matched changes in the country as a whole. The islanders, whose educational needs were quite neglected until the crisis of the late 1890s, were clearly eager to take advantage of the opportunities finally afforded them.

Information is scant about the Barren Island School before the late 1890s. In the Barren Island section of Stiles's massive 1884 history of Brooklyn, DuBois merely noted that "a district school is maintained."[282] This school

was apparently established as a result of parental demands. At the time of annexation of Flatlands by Brooklyn in 1896, the *Eagle* reported that "the parents of the scholars…secured the establishment of the branch on the island by petition to the state superintendent of public schools."[283] Unfortunately, state education records were destroyed by fire in 1911, along with many other state records, so it is impossible to know the details of this petition: how many parents signed it, what arguments they made to the state or anything else. But even this tidbit of information tells us that Barren Island parents, who were almost all new immigrants or African Americans, did have the wherewithal to speak up for the educational needs of their children even in the very early days of the island. In 1890, the *Sun* observed of the island's residents that "sixty of their children are old enough to go to school, and there is a schoolhouse for them. It is by far the most pretentious building on the island."[284]

This "pretentious" building had fallen into terrible disrepair less than a decade later, as detailed below. Problems were foreshadowed by concerns expressed at the time of annexation, when the Brooklyn Board of Education assumed control of Flatlands schools. The same article that mentioned the parents' petition that led to the school's establishment also suggested that the continued existence of the school might be untenable. According to the *Eagle*, the Barren Island School "has forty scholars but only one teacher, who teaches all grades. It has been suggested that this branch might be abolished and its pupils provided with sitting in the new school house [planned for Flatlands…but] the Barren Island children would then be obliged to cross the bay in going to school."[285] This was not realistic. In fact, because of its isolation, it was even difficult for Brooklyn school administrators to check on the school at all. After the annexation, the Brooklyn superintendent became responsible for a much more widespread group of schools. From his office in downtown Brooklyn, "it is a little more than seven miles to the most distant school [on the mainland of Brooklyn], to say nothing of the one on Barren Island, which now has sixty pupils."[286] (The fact that forty pupils were reported in January and sixty in April speaks to the lack of reliable information about the school at this time.) Concerns continued as Flatlands was absorbed into Brooklyn and then that city contemplated its consolidation with New York. The board of education was meant to supervise all of Brooklyn's schools, but "the business men of the board of education cannot afford to take the time that a visit to that school would require, and it would take the superintendent at least the whole of a day to visit it and go over its work."[287] Later reports confirmed that more supervision and care were needed, as it became clear

that the principal frequently closed the school during this period, if he was sick, lost his glasses or some other obstacle arose, making the children's education quite inconsistent.

The Brooklyn Board of Education finally found the time a couple of months later, when a committee of board members visited the island. According to the *Eagle*:

> *They were received at the frame school house on the island by Principal Spencer A. Wallace and the children and Mr. Wordsworth* [of the board] *addressed the pupils, informing them that now as they were under the care of the Brooklyn Board of Education, they were going to have a new school house built. It is the intention of the committee to have a frame building erected, with separate class rooms, at a cost not to exceed $3,000, and to furnish two extra teachers. There are thirty boys and twenty-five girls attending the school.*[288]

A couple of weeks later, the *Eagle* optimistically predicted that "in September…Barren Island will come into the system with a building capable of accommodating about 200 children."[289]

Though this sounded good—and correctly anticipated the growth of the island population—it appears that exactly no action was taken to build a new school. A crisis arose at the beginning of the new school year. The upper story of the school building was occupied by a tenant family named Otts or Ottsage (news reports were inconsistent). The father of this family became seriously ill, perhaps with typhoid fever or black or malignant diphtheria. Fearing contagion, principal Spencer Wallace notified the board of health and was instructed to close the school. Two board of health officials visited the island, and Wallace took full advantage of their visit, and the interest of reporters, to register a number of alarming complaints. He said that there were other cases of illness on the island (although the visitors were unable to find them) and that very close to the school were filthy ponds filled with refuse from the fish and fertilizer factories. A visiting reporter described one such pond located fifty feet behind the schoolhouse: "In this pool pigs wallow to their heart's content and refuse is dumped there without thought of removal and the whole mass is left to decay under the sun. From it arises a smell that penetrates in all directions."

The school building was clearly on its last legs. The same article described it as follows:

The school house itself stands on six piles of rotten wood. The structure is open at the bottom, although a feeble attempt has been made to board it up. It is a two story house, old and nearly fallen to pieces. The winds from the ocean have given it a slant and Mr. Wallace, the teacher, is now unable to open the windows in the front of the school room. The school room occupies the whole floor down stairs and has a seating capacity for thirty scholars. At present Mr. Wallace is crowding fifty-six into it every day that school opens.

Wallace was in despair at the state of the building. He mentioned to the *Eagle* reporter that he had closed the school for two months the previous winter because he was sick, in his view "just on account of the building." When confronted with Wallace's complaints and the observations of the board of health officials, the Brooklyn Board of Education's superintendent of buildings "said that just as soon as possible a new school building would be built."[290]

Once again, and in spite of the clearly urgent need for immediate action, nothing happened. The school reopened once the illness had passed. (Board of health reports indicate that three members of one family died of diphtheria in 1897, but there were no more reports of serious illness.) Board of education records for the 1897–98 school year list fifty-six children on the official register, with an average attendance of thirty-five students—only 63 percent.[291] Given the descriptions of the building, and the likelihood that the overburdened Wallace was probably not a very effective teacher under the circumstances, it is not surprising that attendance was so low. Without a new building or additional staff, things went from bad to worse without the outside world taking notice.

Finally, in 1899, a new crisis occurred and forced the authorities to pay attention to the tiny school on the remote island that was, undeniably if improbably, part of the newly consolidated New York City. As the *Eagle* reported tersely on February 25: "Spencer A. Wallace, principal of the Barren Island School, is in the custody of the police. An examination will be made as to his sanity.…He was taken into custody while loitering in front of the Hotel Brandon on lower Fulton street. He said he was engaged in an important work, that of watching some conspirators who were trying to ruin the school system of Brooklyn."[292] As suggested by reports in several other newspapers as well as the *Eagle*, Wallace had apparently suffered a mental breakdown after years working in intolerable conditions. Charles M. Chadwick, a school board member who took on a leadership role in responding to the situation, "said that there was

no doubt the collapse of the principal was due to his worriment over the condition of the school," especially after a recent blizzard that had damaged the building further.[293]

Chadwick attempted to visit Barren Island with the borough superintendent to investigate further, but, perhaps fittingly, they were prevented from doing so "because the bay was so rough that no tug Captain would risk taking them over."[294] As a result, officials had to rely on second-hand information as they tried to deal with the closed and deteriorating school. At the dock, Chadwick interviewed islanders who were also waiting for a boat to make the crossing. They reported in general that "all the arrangements for the school were scandalously bad" and that even a well teacher would not have been able to manage. In Wallace's case, "of late he had been very irregular in holding sessions, often excusing the entire school after a few minutes work without apparent reason."[295] An islander quoted a bit later opined bluntly: "He had probably been a good enough teacher in his day, but he was worn out when he came. You know this is the dumping ground for worn out stuff, and anything is thought to be good enough for us."[296] The locals also told Chadwick that there were "100 or more" school-aged children on the island, which seems to have been a pretty accurate count: the 1900 federal census listed ninety-two children between the ages of six and fifteen on the island.[297] This indicates that the register of fifty-six and daily average attendance of thirty-five were likely even more of a problem than might have been thought. It also shows that there was no effective mechanism in place to provide sufficient teachers relative to the school-aged population of an area.

With no teacher at all, the Brooklyn Board of Education could not defer action any longer, as it had in the past. "Superintendent Maxwell and others" suggested it was too much trouble and expense to build a new schoolhouse and recruit teachers to this very unappealing site, but Chadwick explained that there was no other option. The children had a right to schooling; transporting them elsewhere by boat was not feasible. "Storm and fog make transportation irregular and the boat service is inadequate," Chadwick stated in his official report to the board.[298] Regarding the very real difficulty of recruiting and retaining teachers, Chadwick made the proposal that the new schoolhouse include apartments for the teachers and janitor. The board approved a resolution to build a new, two-story, six-classroom building with living space on the second floor. It agreed to do so "within ninety days from the passage of these resolutions," an ambitious plan that would have meant it would be ready in June 1899. This was quickly found to be unrealistic.

The building of the new schoolhouse did proceed this time, though on a much slower schedule than planned. It is not clear whether school reopened at all in the spring of 1899, but in the fall of that year, school sessions were held in the Catholic church, with half of the children attending in the morning and half in the afternoon.[299] That summer, the new building was expected to open for the beginning of the 1900–01 school year,[300] but when that time came, the *Eagle* reported that "the new school house at Barren Island will…be delayed in opening and the exact time when the building will be ready cannot be stated."[301] Soon after that, it was reported that "the original contractor on this work failed" and that the school would open in January 1901.[302] A principal named Professor Johnson was hired and began a fundraising campaign among the children to pay for a new American flag. Johnson also managed to attract the interest of "a number of men living in Canarsie" who "decided they must do something also for the school." They, too, bought a flag, and a ceremony was held to celebrate the purchase of the new flags. On that occasion, the *Eagle* explained that "school is now being held in different places" and also mentioned the special responsibilities of Barren Island schoolteachers: "The teachers do a deal of mission work. They look out for the comfort and welfare of the pupils in more ways than one. On Thanksgiving Day, a good dinner was provided for the seventh primary grade and the kindergarten. Two of the teachers prepared it and one of the ladies on the island did the cooking. Several of the large girls acted as waitresses."[303]

The schoolhouse did finally open for the spring semester in 1901, two years after Spencer Wallace was found wandering dementedly around Brooklyn, and three and a half years after the reports about illness and decay of the building. Thus began the next phase of Barren Island's educational system. Starting at this time, the school was often seen by outsiders as a surprisingly bright spot on a bleak landscape. A report in the *Eagle* in August 1901 stated: "The kindergarten at Barren Island is in a pleasant room in the new school building which was opened this spring. It is a fair sight that greets the eye from the windows looking over the waters of Canarsie Bay, with the fisherman's boat and the sea gulls flying wild and free.…[The] children in the kindergarten are bright, active little people, in love with nature and the sea by which they are surrounded."[304] This same article painted a dismal picture of every other aspect of Barren Island, describing it as "sordid" and "miserable," filled with drunken murderers and white women who would dance with black men. The principal, Daniel Edwards, responded, contradicting the negative observations but agreeing that the school was a

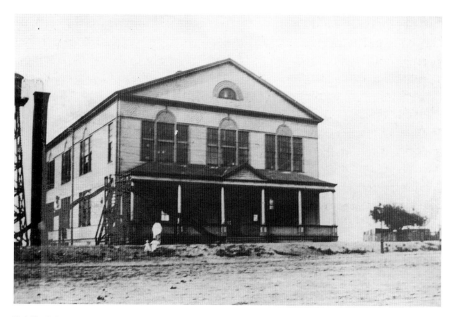

Public School 120, which opened in the spring of 1901. This building replaced a dilapidated one-classroom structure that was viewed as the cause of principal Spencer Wallace's nervous breakdown. Circa 1904. *Lee A. Rosenzweig collection.*

special place whose students were "neat and clean" and "remarkably healthy and bright"; the new school building "has become their peculiar pride."[305]

Similar reports of the school's striking cheerfulness and the children's intelligence and good humor appeared in subsequent years. More capable teachers were hired. In 1902, Harriet R. Dailey, who had apparently been teaching there since 1900, took over as acting principal (later teacher-in-charge; she probably did not have the correct qualifications for a permanent post as principal). She stayed until at least 1913, according to board of education records.[306] According to the *Eagle*, "she has been for eight years on this bleak waste amongst these simple folk, seeking not only to uplift the children, but the fathers and mothers and the older boys and girls." In 1908, when this article was published, the school had 170 students, described as follows: "two-thirds of them are Poles and the remainder Italians, with a few Germans and colored children." Dailey described her efforts to provide books and to keep the older boys out of the saloon. She also explained that she and the teachers visited the mothers at home to "show them how to tidy up and how to cook," much like the domestic educators described in chapter 2.[307]

This approach on the part of the teachers, with the goal of assimilating Barren Islanders into the mainstream of American life (at least as the teachers perceived it), was echoed in a 1910 article that discussed the difficulties in recruiting and retaining teachers. Those who sought out work on Barren Island were said to be "endowed with the missionary spirit," having the laudable desire to Americanize the inhabitants. (The same article bluntly stated that teachers were sometimes assigned against their will to the island specifically to stop them from visiting board of education headquarters with excessive complaints. If they were on Barren Island, they would be physically too far removed to complain.)[308]

This effort toward Americanizing was described repeatedly. During the height of the Ellis Island era of immigration, with millions of immigrants arriving annually from Eastern Europe alone, assimilation was a serious concern for many native-born Americans. According to the *Eagle*, at Barren Island, "the duty of the teachers is to take the children and, through the smelting pot of the public school, transform them into American citizens."[309] It is unknown exactly how the Barren Island children and their families felt about this smelting process. Visiting reporters focused mainly on the teachers, often reporting that the children were intelligent and polite, but no attempts were made to understand their experiences from the point of view of the children themselves. Around the same time, a night school was established to teach English to the adults. Again, the students were not interviewed, but a visitor did report that there was "a class of thirty pupils, men and women. Most of them are foreigners, learning the language, and they are earnest students."[310] Since the adults were voluntary students, unlike the children, this implies that there was an active wish on the part of at least some adult Barren Islanders to learn English and settle in to their new country, though they also retained ties to their home countries, including sending large amounts of their pay as remittances. Both of these articles also stated that some islanders had come directly to Barren from Ellis Island without ever setting foot elsewhere in America.

The teachers' "missionary spirit" was required not only because authorities saw it as their role to assimilate the children and families, but also because conditions on the island sometimes resembled those at remote outposts where one might expect to find actual missionaries. Even after the new building was finished, teachers struggled with basic housekeeping tasks. Until 1911, they had to collect rainwater in a cistern for drinking, cooking, washing and bathing, and there was not always enough: "sometimes they were restricted to a pint a day for washing purposes."[311] In 1911, the city

dug a well, seeming to solve that problem, but soon afterward, the pipe between the well and the teachers' cottage broke. Of course, teachers, who lived on the island from Monday to Friday, also had to contend with the inconsistency of ferry service during bad weather and could not always get home for the weekend—or back to school for the week; from late January until February 13, 1918, the school was temporarily closed because the teachers could not get there.[312] It is not surprising that the school had difficulty retaining teachers. In February 1918, the board of education increased the teachers' pay from $4 to $4.50 a day, because it was "becoming increasingly difficult to secure teachers who are willing to go over to the island." Once again, the possibility of shutting down the school altogether was raised and rejected.[313]

For almost all of these years, the Barren Island school, "the one bright spot for the children of that desolate place," ended in the seventh grade.[314] In 1911, the school offered eighth grade, but for all of the other years in the early 1900s, the first or second semester of seventh grade was the last offered.[315] This meant that children were not qualified to start high school when they left PS 120. When asked whether Barren Island children went to high school in the city, former resident Josephine Smizaski, who lived on the island from 1908 to 1918, responded, "I don't think anyone thought of high school." She explained that islanders simply went to work after they finished at the island school. While there is little direct evidence of islanders' feelings about this situation, increasing nationwide high school attendance, combined with the fact that once eighth grade was consistently offered starting in 1918, most island children continued on to high school, suggests that if eighth grade had been offered earlier, many islanders would have taken advantage of it.

It was in 1918 that the Barren Island School entered its most successful phase of existence. The shift began in March, when Mrs. Isaac Franklin Russell, a member of the New York City Board of Education, became the first in memory (probably the first since the 1897 visit) to actually visit the island. She had heard that PS 120 had been closed for over two weeks because of bad weather and cancelled ferry service. Russell, along with several administrators and an *Eagle* reporter, visited. On March 12, she found that "there are 224 children in the school, 60 per cent of whom were in attendance.…For lack of teachers no effort is being made to compel the children to attend." Like many other visitors, she was both interested and appalled to learn that trash-picking was the favorite hobby of the children. The visitors noted that the building, no longer new, had broken windows and

From left: the teachers' cottage, PS 120 and a neighboring house, 1936, with marsh visible in the foreground. Brooklyn Daily Eagle *photographs—Brooklyn Public Library—Brooklyn Collection.*

a boiler in need of repair. After observing conditions on the island, Russell concluded, "There's a lot of missionary work to be done there."[316]

Russell went to work seeking a head missionary. She found her dream candidate in Jane F. Shaw, a veteran of the New York City public system and member of a family of distinguished sister teachers from Utica, who had been teaching "defective children" at PS 12 on the Lower East Side of Manhattan for fifteen years. Shaw agreed to the board's request that she spend a year as principal of PS 120. Within a couple of months, "a new spirit had taken possession of the place." Shaw took a savvy approach to media interest in her quirky post and made the most of every opportunity to get the word out about the islanders' special qualities and special needs. She told an *Eagle* reporter that she was "very much touched by the willingness of these children to do for others. So little has been done for them I feel they must get the inspiration from 'the blue above.'" Certainly the implication was that much more ought to be done for these deserving students. Shaw was also very skilled at commanding the attention of school administrators, nonprofit organizations and businessmen who might be looking for a recipient of well-publicized charity. In that initial article, she made sure readers understood exactly what she was up against and how she was handling it. A wave of

influenza (part of the worldwide Spanish flu pandemic) and pneumonia had passed through the island that fall, and Shaw had persuaded the Red Cross to provide fresh milk to the islanders daily. "Every morning the boys met the police boat and loaded the milk into pushcarts, dragging the loads through the heavy sand, and delivered it to the homes of the sick," she reported.[317]

She was also mindful of the benefits of portraying her students, mostly immigrants themselves or children of immigrants, as patriotic Americans. During World War I, Americans were encouraged to collect peach pits, because they could be converted into activated charcoal, which was used in gas masks as an antidote to the chlorine gas used by the Germans.[318] Shaw organized peach-pit collecting on the island. The students gathered twenty bushels, inspiring a letter from Marcus L. Filley, a Red Cross representative, who wrote, "When at the request of their principal, children will do work like this for their country, what splendid Americans we may look for as the boys and girls reach maturity."[319] Just within her first two months on the job, Jane Shaw had shown that she was ready and able to use creative and forceful means to advocate for the islanders, to improve their image in the public mind and to give them opportunities they had long been denied.

Shaw continued with this approach when the garbage plant closed in 1919 and the island population shrank. Now the only regular factory work was at the horse factory. She initiated an ongoing relationship with the Red Stocking Committee, a group of philanthropic women who put together Christmas stockings for needy children and reaped the reward of positive press attention. The first Red Stocking Committee delivery came at Christmas 1922, and these continued for at least three more years. A typical report in 1925 in the *Eagle* described the program as follows:

> *Barren Island, that forsaken spot in Jamaica Bay where the garbage disposal plant used to be and which until the new causeway* [the Flatbush Avenue extension] *was put through was as much cut off from New York City as if it had been a thousand miles away, has been one of the Red Stocking Committee's pet protégées. These children never see the city sights, have no stores on the island and never get a toy unless through the red stockings. They are most of them shockingly poor and the warm underwear, two sets for each child, that go into the stockings are a Godsend to the little folks.*[320]

In spite of her powerful presence, Shaw still had trouble retaining teachers. Teacher salaries on the island were again increased beyond that of other city teachers in 1923, this time by $300 a year. The board member who made

the proposal "declared that it was 'punishment enough to have to live there' and that the teachers deserved the extra money."[321] Once again in 1927, the board suspended its own bylaws to increase teacher salaries. Even once the Great Depression began, unemployment was high and the Flatbush Avenue extension had been built—making the island a bit more accessible—it was hard to find teachers. In 1931, the *Eagle* reported that when PS 120 needed another teacher, "91 persons, who had been declared eligible by the Board of Examiners, refused rather than maroon themselves in the little community." (Luckily, Mildred Sauerbrunn agreed to take the position and said she was "only too happy" to have it.[322]) Though this was perhaps an extreme case, it illustrated ongoing difficulties in teacher retention that must certainly have had their effect on the education of the students.

Yet somehow, under Shaw's leadership, the school developed into a very popular place among the islanders. Its attendance was frequently among the highest in the city. Starting in late 1926, the *Eagle* often made reports like this one: "P.S. 120, a little elementary school on Barren Island with only six classrooms, again led the city in attendance figures for the month of March, 1927, it was announced today by the bureau of attendance for the Board of Education. This school had an average attendance of 99.12 percent for the month."[323] By the following school year, this was considered the norm: "As usual the elementary school in Brooklyn with the best attendance record was P.S. 120, on Barren Island."[324]

Though the world was changing around them, and Floyd Bennett Field started introducing the latest in aviation technology to Barren Island residents in 1931, the Barren Island community was still very isolated for most practical purposes. The Flatbush Avenue extension connected the island to Brooklyn, but most islanders did not own cars, there was no bus service yet and it was three miles to the nearest trolley. (In fact, the distance contributed to Floyd Bennett Field's ultimate failure as a municipal airport after the much closer LaGuardia, then known as the New York Municipal Airport, was built in 1939.) Jane Shaw continued her unflagging efforts to draw the attention of do-gooders and municipal authorities to the place she declared "the most moral spot in New York City" with "the gentlest, most honest and friendly people." She explained to a visiting reporter that it was wrong to refer to the islanders as "squatters," and she highlighted their creative efforts on their own behalf:

> *When the city refused to build a road in from the causeway, they chipped in to the extent of $800 and built a board road, which every one uses. They*

get their water from artesian wells, which we've built ourselves. The ground is exceedingly fertile—thanks to the old garbage plant that used to be on the island. Every one raises his own vegetables. The school children have their own large and well-kept garden, from which they take home enough vegetables for lunch two or three times a week. Most of the residents have their own chickens, ducks and cows. Sunday is still the day for chicken dinners. It is a most self-contained community.[325]

Interestingly, though Shaw was recruited by Russell to act as a "missionary," she was never herself quoted as using that term or anything similar. She appears to have had a genuine respect for the islanders, she appreciated their skills and positive attitude and she was devoted to the notion that their children deserved the best possible education. The pity and condescension apparent in many other outsiders' comments—no matter how well-meaning—were not part of Shaw's mindset.

She also saw that the education of children was really only one aspect of her responsibilities. Understanding that it would be hard for her students to learn if their other needs were not met, and if their families were not respected by the authorities, Shaw got basic medical training and made herself available to treat minor illnesses and ailments.[326] She successfully demanded that the U.S. Census Bureau, which had skipped over the island in 1930, come and count the residents. (Those records show that Mildred Sauerbrunn, the teacher who took her job after ninety-one others had declined it, did the census enumeration for Barren Island.[327]) She gave cooking and English lessons to the parents. She even created street names and house numbers for residents to use as their addresses, along with the new neighborhood name "South Flatlands," after some of her former students, now high schoolers, reported that they felt embarrassed to have the simple address "Barren Island." (The 1930 census noted street names like Main Street and Spencer Place but continued to use the neighborhood name of Barren Island.) She also attended to islanders' recreational needs, obtaining a movie projector, roller skates for all the children and a library for both children and adults.[328]

Many of these accomplishments were not only noted by newspapers at the time that they occurred, but they were also remembered by former residents many years later. When William Maier was interviewed in 2012—more than seventy years after he graduated from PS 120—he recalled the roller skates and other Christmas gifts, the visits from "Santa" (a police officer from a nearby precinct recruited by Shaw), the gold pin Shaw gave

to every eighth-grade graduate, as well as the love Shaw had for the islanders in general. He remembered her critical stance toward cigarette smoking: she "was dead against it. She used to say to us boys, 'A fool at one end and a light at the other.'" Even as a child, he was well aware of her influence over powerful people, recalling that Shaw knew "people in City Hall. She obtained a lot of favors that I think we would have never obtained. It was a great thing to have somebody like that in our corner…a real politician." As Maier summed it up, "What a person she was!"

Another such person was the school janitor, Noah Decker, who worked there from 1919 until his death in 1932. Unlike Shaw, Decker was reportedly devastated to be posted to this remote location, far from his family on Staten Island. In fact, "he was thoroughly disgusted with the place" upon his arrival. But he watched with admiration as Shaw and the other teachers gracefully and effectively handled the influenza epidemic that broke out soon after his arrival. Decker was soon a convert to the positive aspects of life on Barren Island, and he "came to cherish the desolate place with its hardy settlers," much as Shaw did.[329] "Inspired by the example of the women teachers," Decker organized a volunteer fire department and started an evening class to teach children about wireless radio technology.[330] Ultimately, also like Shaw, he refused the board of education's offer to transfer him to a more attractive location. In his obituary, the *Eagle* reported that "he came to be one of the most beloved figures of the community."[331]

Shaw, that "bright little human dynamo of a school teacher,"[332] continued her work even after a serious fall at a school basketball game on February 27, 1935. She fractured her pelvis and injured her hip in this accident, and doctors determined that her heart was too weak to survive the necessary operation. (She was then sixty-eight years old and had been eligible for retirement for some time.) So, Jane Shaw simply began to teach the seventh and eighth grades from her sitting room while "reclining in a narrow blue bed from which she may never get up again." The children came over, moved the furniture so that they could hold class and got their education. After 3:00 p.m., she would hold court as younger children, their parents, the priest and others came to visit. "Miss Shaw spoke fondly of her beloved island, which is no longer an island, and her beloved people. In 17 years she has never had the need of a truant officer. She has never had a court case. There has never been a wayward girl. Her pupils grow up and marry and live in the little shacks that dot the marshy lowland." Shaw was also very proud that almost of all of her graduates went on to high school.[333] By now, there was a bus they could take along Flatbush to the trolley stop. William

Maier later remembered his commute to Erasmus Hall by bus to the trolley, which took him to school on Church Avenue. (His mother gave him twenty cents for transportation every day, five cents for each bus and trolley trip.)

In spite of her deteriorating health, Jane Shaw continued teaching until the end of the school year in June 1936. She had succeeded in persuading Robert Moses to move the eviction date from April 15 to June 26 so that her students could complete the school year.[334] Shaw retired and moved back to Brooklyn. She died at seventy-two on September 3, 1939, and was memorialized in an obituary in the *Brooklyn Eagle* that described her as "the guardian angel of Barren Island."[335] Put another way, as former resident Julie Gilligan said in a 2000 interview with the *New York Times* at the age of eighty, "She wasn't just a principal, she was a mother to everyone."[336]

Although Jane Shaw was an individual, an outsider (at least at first) who had a clearly visible effect on Barren Island and its residents, her achievements should not cloud the fact that islanders themselves were active agents in their own progress. Shaw herself always made a great point of observing that islanders—usually nameless in news reports—worked very hard for their own success and that of their children. She clearly felt that she got at least as much back from the islanders, in terms of personal fulfillment, as they got from her. And she was clear-eyed about the limits of her accomplishments. There was never adequate fire protection for the island, in spite of her and Decker's advocacy. Shaw also noted that the state failed to enforce its hunting laws regarding "birds and fowl, which are openly killed by Sunday visitors." With the coming of Floyd Bennett Field, these examples of neglect were even more jarring. "Overhead, a bright yellow plane winged its way homeward in a murky sky," approaching "ultramodern Floyd Bennett Flying Field," while Shaw lay in bed teaching class.[337] As she said, pointedly, to an *Eagle* reporter in 1931, New York had provided "$4,000,000 for an airport and not even $6,000 to give Barren Island a water supply and good roads."[338]

The juxtaposition of the most advanced aviation technology with the still-neglected, still-remote, quasi-island characterized the last years of Barren Island in the 1920s and '30s. Islanders knew their community's days were numbered after the garbage plant permanently closed its doors in 1919. With the building of the Flatbush Avenue extension and the erection of Floyd Bennett Field, the end of Barren Island was only a matter of time. Many residents moved away when they lost their jobs at the garbage plant. Yet the islanders who remained continued to creatively build and maintain their community, integrating the excitement of the airport into their existing world of marsh, sea and dead horse processing.

THE END OF BARREN ISLAND

When they finished that road to Avenue U…that was basically the end of
Barren Island as Barren Island.
—*William Maier, former Barren Island resident*

Barren Island residents have practically moved into a new world. It is not so
much that these people have moved, but the new world has come to them.
—Brooklyn Daily Eagle, *February 7, 1926*

Barren Island, one of the most picturesque rural communities within Brooklyn,
was to lose the last of its 400 inhabitants today.
—Brooklyn Daily Eagle, *June 26, 1936*

Today, visiting Floyd Bennett Field, or driving smoothly from Brooklyn to the Rockaways over the Gil Hodges Marine Parkway Bridge, one would never suspect that this place had once been a remote island. The end of Barren came in stages. New York City was continuing to grow in population, and its outer edges were urbanizing. The development of Coney Island, the Rockaways and other neighborhoods in the Jamaica Bay area revived the complaints about the smelly, unsightly island that didn't seem so remote anymore. In 1919, amid a chorus of grievances, the city ended garbage processing on the island—though not yet animal rendering—once and for all. Not long after that, in the mid-1920s, the Flatbush Avenue extension, a three-mile road that connected Barren Island

to mainland Brooklyn, was built. A ferry service to the Rockaway peninsula was established, so many beachgoers would drive to Barren Island and then take the ferry to the Rockaway beaches. (The still-visible vestiges of the piers from this ferry service are the only remaining visible trace of Barren Island's life as a residential community.) Meanwhile, with the increasing use of the automobile and corresponding decrease in the number of horses in New York, the need for rendering was diminishing; the rendering plant closed in 1934. Finally, just a few years after Flatbush Avenue was extended, Barren Island, the once peripheral, forgettable bit of marsh in the ocean, became the central and essential site of the city's first municipal airport, to and from which pilots might fly for thousands of miles in the most up-to-date "ships." Perhaps inevitably, then, in 1936, the last of the islanders were evicted. The city initially gave them only a couple of weeks to leave to make way for the Marine Parkway Bridge to the Rockaway peninsula and for a planned expansion of Marine Park itself (which did not come to fruition).

The decaying piers of the Barren Island ferry to the Rockaways, built at the time of the Flatbush Avenue extension in the 1920s. These piers are the only structures remaining from the island's residential community. *Photographed by the author in 2018. Author's collection.*

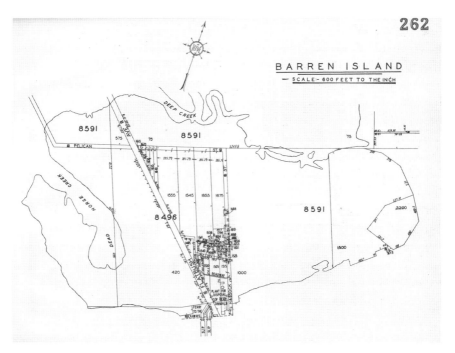

E. Belcher Hyde map of Barren Island, showing the Flatbush Avenue extension, new street names, the dead animal factory and the ferry to the Rockaways, 1929. *Author's collection.*

All of these changes, which took place over less than two decades, had a dramatic effect on the Barren Island community. The final closure of the garbage plant in 1919, amid much political squabbling, did away with many jobs and led many islanders to move away, shrinking the population. The Flatbush Avenue extension, though unpaved at first, suddenly made the island much more accessible, which had both positive and negative consequences. PS 120 graduates could take the bus to high school, and islanders could commute to jobs, in Brooklyn proper. Likewise, Brooklyn residents could drive to Barren Island, either to take the ferry to Rockaway or, a bit later, to watch the airplanes at the Barren Island Airport (a private airstrip) and Floyd Bennett Field. No longer was the community an isolated and ignored spot. William Maier recalled watching the cars on Flatbush go by as he and his friends learned to identify the different makes and models, on the same spot to which the first car had been driven over the ice only a few years earlier.[339] And when the airport rose up, the islanders must have known that other big changes were inevitable; a residential neighborhood could not coexist for long on practically the same land as the city's municipal

airport. During the time that the Barren Island community and the airport overlapped, residents enjoyed watching and taking part in recreational flights, got to know about different types of aircraft and the celebrity pilots of the time and also witnessed terrifying accidents. By the time of the eviction in 1936, there was no organized opposition to the move, simply a request for a brief extension so that children could complete the school year. Many families, like Maier's, left ahead of time and established successful new lives elsewhere (his family moved upstate and bought a farm in 1935), while others had a more difficult transition, including a few who overstayed the eviction notice.

As described in chapter 2, residents of nearby communities had been complaining about the smell produced by Barren Island industries practically since their inception. However, no one had come up with a viable alternative plan for New York City waste, and those communities had generally been sparsely or seasonally populated. As the city grew, though, and garbage-processing technology developed, new ideas and complaints were voiced. In 1918, the *Eagle* reported that a new company on Staten Island, the Metropolitan By-Products Company, had built a plant that was "physically capable of handling the entire garbage output of the City at the present time." It theoretically would process the garbage without creating offensive smells.[340] This sounded promising, especially at a time when garbage was not being processed on Barren Island due to fires at the garbage plant; instead, it was being dumped at sea. Ocean dumping was frowned upon for two main reasons: one, it created an unsightly and disgusting mess that tended to wash up on beaches; and two, it was expensive and, unlike garbage reduction, did not create any products that could bring a profit. (The health of the ocean ecosystem was not a consideration.)

However, just a day later, a contradictory report was published saying that the "Staten Island plant [was] not meeting the city's demands" and that the Barren Island plant had reopened.[341] This ignited a new wave of complaints and demands. Just a few months later, Mayor John Hylan promised that the city would stop garbage processing at Barren Island by April 1919, even if that meant ocean dumping had to resume. He was responding in part to pressure from his health commissioner, Royal S. Copeland. Perhaps surprisingly, even though the germ theory of disease was well established at this time, Copeland, a physician who helped the city handle its response to the Spanish flu epidemic around the same time, repeatedly referred to health threats that he said emanated from the Barren Island smells. Copeland stated that not only were the smells

"obnoxious, disgusting and filthy," but also he was concerned about "the impairment of health of thousands of our citizens."[342] Hylan agreed and, in fact, beat his own April deadline by shutting the Barren Island garbage plant, permanently, on February 15, 1919.[343]

Throughout these debates and the on-again, off-again shutdowns of the garbage plants that had gone on for years, media reports made no mention of the people whose livelihoods depended on the plants. Broad statements like "the people of Brooklyn have won their fight against…the garbage rendering nuisance on Barren Island" carried the clear implication that Barren Islanders themselves did not really count. It is hard to know for certain how islanders responded to the February 1919 shutdown.[344] Most likely, it took some time for its permanence to feel real; there had been so many earlier temporary shutdowns due to fires and political fights. Many islanders moved away at this time; the population dropped by at least half between the 1910 and 1920 federal censuses.[345] Josephine Smizaski, born on the island in 1908, recalled that this was when her family moved to Jersey City. Considering islanders' practical-minded response to so many other challenges, from the lack of firefighting equipment to the need for drinking water, it seems likely that they generally accepted that times were changing and made the decision to stay or go based on what seemed right for their families without too much fuss. In 1920, the garbage factory's land went on the real estate market. Although it was advertised as a set of twenty-seven buildings on eleven acres, "particularly adapted for chemical, paint and color concerns, oil industries and storage," no new factories opened; the city ultimately acquired the land.[346]

The earliest signs of Barren Island's impending shift from the edge to the middle of New York City came even before the garbage plant closed. In 1907, Flatbush residents began advocating for an extension of Flatbush Avenue to Barren Island. In fact, in the first mention of such a plan in the *Brooklyn Eagle*, the idea was floated of continuing the avenue straight across the water not only to Barren Island but also all the way to the Rockaway peninsula.[347] (The Marine Parkway Bridge, which eventually made this vision a reality, was erected in 1937, a decade after the Flatbush Avenue extension.) Later in 1907, more specific plans were proposed. The *Eagle* noted that marshland would have to be drained and filled, a process that had already been successfully implemented in other waterfront Brooklyn neighborhoods, like Canarsie. This article predicted, correctly, that once such a road was built, the use of Barren Island for garbage processing would be even less palatable to New Yorkers.[348]

Over the coming years, city engineers undertook the planning and surveying needed to determine whether this broad plan was realistic. They concluded that it was, and in 1913, the New York City Board of Estimate (the city government body which was at the time responsible for much decision-making and budgeting) authorized the building of the extension.[349] Turning this into a reality, however, took many more years. William Maier remembered the dredging, filling and leveling that made the road possible. Pipelines to drain the marshes ran close to his home. (He recalled that "if you had a good arm, you could throw a baseball where the pipeline went past our house.") Though residents could not get too close, they could watch the action from a safe distance. Eighty years later, Maier still remembered the Portuguese workers, in their waterproof rubber outfits, chanting in unison to coordinate the use of a battering ram.

Finally, in 1925, the road was finished. The *Eagle* took note of its possible effects on the island population. "Shut off from the mainland for many years these island dwellers have seen little of the surrounding country and the little school children, 107 of them, have been content with their own island world. All this is changed through the connection of Barren Island with the mainland at Flatbush ave." The article went on to note that "the section is entirely changed from a desolate waste spot to one of great activity. Motorists have been quick to seize the opportunity to get to Rockaway in a hurry and those without motorcars have also been afforded the opportunity to visit their Rockaway friends by means of bus transportation to the new ferry landing."[350]

Barren Island, for so long on the very outermost edge of the city, was now literally in the middle of things, at least as far as many beachgoers were concerned. The islanders were aware of the significance of these changes. When the Rockaway ferry started service, the Barren Island children welcomed an automobile parade by lining up on the road and waving American flags at the cars. From the beginning, traffic was described as "very heavy," including both cars and buses.[351] William Maier remembered the traffic, as well as islanders' creative responses to its arrival. He and a friend planned to lay down tar paper behind his house and charge drivers to park there. Maier also noted that the Flatbush Avenue extension offered a new educational and economic opportunity to his family: his older sister, Matilda, went to business college and then got a job as a secretary at a department store on Fulton Street in downtown Brooklyn. She was only able to take these steps because of the Flatbush Avenue extension. Willie Maier himself attended high school at Erasmus Hall on Church Avenue in

the early 1930s—again, only because of the road. So, while the Flatbush Avenue extension was one crucial event that helped make the end of the Barren Island community inevitable, it simultaneously offered new prospects to island residents, thus easing their transition to life after Barren Island.

The last aspect of the last chapter of Barren Island's existence was, of course, the airport. In fact, there were two airports. The Barren Island Airport was a small strip built by the pilot Paul Rizzo that opened in 1927. According to the National Park Service, this strip "was located west of Public School #120 and included two hangars."[352] Rizzo was self-taught at a time when flight instruction was not standardized. William Maier remembered Rizzo piloting both a Curtiss Jenny and a Waco biplane. He and other pilots would take paying customers up to fly around, and they would also do stunts and parachute jumping. As described in chapter 4, the Barren Island kids loved coming to watch the planes. This airport clearly functioned, in part, as a community recreation center. Children who only a few years before had seen their first automobile were now witnessing the cutting edge of aviation. With so many new pilots, accidents were a frequent occurrence and were sometimes witnessed by crowds.[353] Maier remembered a Japanese pilot who crashed, the "Polish plane" that crashed (as well as the local boy who retrieved the tail wheel) and more. In addition to the residents themselves, hundreds of people would drive in from points west to watch the airplanes, turning the Flatbush Avenue extension into a parking lot.[354] It was both an exciting and an unsettling time for Barren Islanders.

Barren Island was selected as the site of New York City's first municipal airport around the same time. Dozens of sites in Brooklyn were considered, and Barren Island had some distinct advantages. Most important, the land was already owned by the city. This would offset the cost of an airport significantly. There was plenty of open space that was mostly unused, and much of the land had already been leveled for the Flatbush Avenue extension. Although the island was not impressively close to Manhattan, it was at least accessible by car and bus. The pilot Clarence Chamberlin, who had learned to fly at the School of Military Aeronautics in Illinois during World War I and later made a living barnstorming (performing flights and tricks for an audience on the ground), had been appointed aeronautical advisor to the city. He recommended the selection of Barren Island. Neither Chamberlin, nor Mayor Jimmy Walker, nor his assistant in charge of the project, Charles F. Kerrigan, apparently saw fit to consider the effect of the airport on the Barren Islanders. The island was depicted in news accounts as essentially abandoned, "a wrinkled desert wasteland."[355]

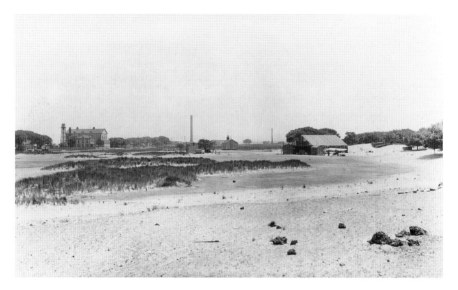

Looking east from Flatbush Avenue, from left: P.S. 120 with the teachers' cottage visible to its right and the tank for collecting rainwater behind it, the garbage factory smokestack, the Protestant chapel and a hangar with airplane next to it. The sandy, grassy expanse is typical of Barren Island's landscape, July 5, 1931. *Courtesy of the Queens Borough Public Library, Archives, Eugene L. Armbruster Photographs.*

The final decision to build the airport was made in 1928, and it was built rapidly.[356] It was soon decided that the airport would be named after Floyd Bennett, an aviator who had flown with Admiral Richard E. Byrd (possibly to the North Pole, although that is uncertain) and who died of pneumonia contracted after a plane crash in April 1928. While in the planning stages, the airport was described as including the latest in aviation technology, including the "first roof-top landing field," two runways, hangars for land and seaplanes and more. A long article about these plans briefly mentioned the "weather-beaten shacks stuck down in the sand on Barren Island," but not the people who lived in them.[357]

Floyd Bennett Field, though incomplete, was dedicated by Admiral Byrd on June 26, 1930, after about one million spectators watched him travel by car through Brooklyn to the airport.[358] Charles Lindbergh led the aerial demonstration. Public interest in aviation was intense. The airport didn't officially open until the following year, when it was "opened to flying operations and dedicated by…672 planes" in May 1931.[359] Meanwhile, the 225-foot smokestack from the old garbage factory continued to stick up like a sore thumb just a few hundred feet away. The city had asked the

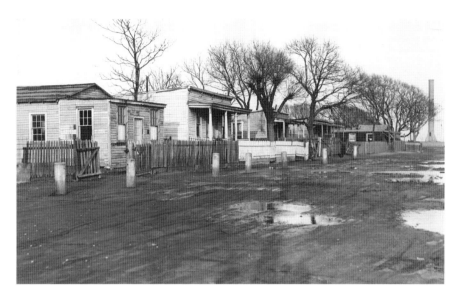

One-story, wood-frame houses on Barren Island—often described as "shacks" by outsiders—with the garbage factory smokestack on the far right, March 1936. Brooklyn Daily Eagle *photographs—Brooklyn Public Library—Brooklyn Collection.*

New York Sanitary Utilization Company to demolish it, but the company demanded that the city pay, and negotiations stalled. The following year, the airport was denied the top rating from the U.S. Department of Commerce aeronautics branch, solely because of the dangers posed by the smokestack.[360] Finally, in 1937, the smokestack was demolished, one of the last remnants of the island's garbage-processing era, after the Barren Islanders themselves were gone.[361]

Floyd Bennett Field was never the great success that its boosters predicted. Newark Airport opened first, was closer to Manhattan and was able to hold on to the all-important postal mail contract. After LaGuardia (then called the New York Municipal Airport) opened in 1939, Floyd Bennett Field was no longer of much interest to commercial aviation. It was taken over by the navy in 1941 and, after World War II, was used as a U.S. Naval Air Reserve station until the early 1970s. Since 1972, it has been part of the Gateway National Recreation Area, under the administration of the National Park Service.[362]

But, however unsuccessful the airport ultimately turned out to be, its establishment spelled the end for the Barren Island community. The rendering plant, rendered no longer necessary by the disappearance of horses from New York City, closed in 1934.[363] The following year, the city

Crowds at the dedication of Floyd Bennett Field. *Brian Merlis collection.*

notified Barren Islanders, most of whom rented their land from the city, that they did not need to pay rent anymore. Not surprisingly, this financial windfall made the islanders feel "worried, perhaps even frightened," since they knew what it must mean. Finally, now that it was too late, the newspapers began to pay attention to the effects of recent changes on Barren Islanders. "To be ousted from their breeze-swept land would be a tragedy for the island men, women and children. Born and raised near the bay, accustomed to the tranquility of the island, the people would be heartbroken if forced to leave," wrote an *Eagle* reporter after interviewing Jane Shaw. The reporter evidently did not interview anyone else; Shaw was often seen as sort of an ambassador or interpreter for the islanders. Shaw explained that the four hundred remaining islanders were getting by through a combination of "little gardens, fishing, odd jobs here and there." She stressed that they valued education and sent their children on to high school. As was her habit, Jane Shaw also spoke up for the respectability of the islanders, explaining: "These people are good, kind, honest folk. They never are involved in anything bad,

A crowd surrounds the plane of Lieutenant Commander Frank M. Hawks on his arrival at Floyd Bennett Field after he broke the transcontinental nonstop speed record from Los Angeles to New York in thirteen hours, twenty-seven minutes. June 2, 1933. *Brian Merlis collection.*

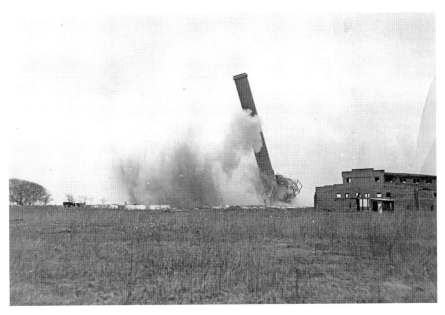

Demolition of the Barren Island garbage factory smokestack, with the factory building itself still present, March 20, 1937. *Lee A. Rosenzweig collection.*

End of the main street, July 5, 1931. *Courtesy of the Queens Borough Public Library, Archives, Eugene L. Armbruster Photographs; Lee A. Rosenzweig collection.*

criminal." Shaw told the reporter that the city should allow the islanders to stay and pay rent. She said that she had asked the Tenement House commissioner, Langdon W. Post, if he could help rebuild the houses to make them stronger and more weather-proof, but he explained that no funds were available. It is clear in the article that Shaw and her fellow residents knew that their time on Barren Island would soon be up.[364]

The eminent reporter Joseph Mitchell also visited the island in this time of decline. Writing for the *World-Telegram*, unlike the *Eagle* reporter, he did speak to a number of ordinary islanders, like "Fred Bottcher, who worked in the glue [horse] factory for forty-three years," and described the demolition of this factory. One interviewee told Mitchell, "For generations these man worked on the city's refuse, risking blood poisoning and other terrors to turn dead animals into useful products, and now they are thrown on the scrap heap themselves."[365]

The following year, the expected eviction notices arrived, and the elegiac tone of news reports continued. In mid-March 1936, residents read notices signed by Robert Moses that stated: "Notice is hereby given the above to vacate these premises on or before March 31st, 1936. You are also notified to remove all buildings and personal property on or before this date. If you fail to remove your property by this date, it will be considered abandoned and disposed of accordingly." In other words, residents had only about two

weeks to find a new place to live and remove all of their belongings. The local alderman, Joseph B. Whitty, persuaded Moses to change the date to April 15; this was clearly still not nearly enough time for most residents to reorganize their lives. Whitty also got Mayor LaGuardia to promise that the Tenement House commissioner "would be instructed to treat the houses on the island as condemned tenements. This means that the squatters will receive free moving van service."[366] The reason given for the eviction at the time was the need for land for the planned new bridge to the Rockaways (which was indeed built in 1937), although later reports cited plans for an expansion of Marine Park (which did not happen).

This was a hard time for the few remaining islanders. An *Eagle* reporter visited soon after the eviction notices were posted and spoke with a number of desolated residents. "Women folk couldn't believe that the time had really come to abandon their mean little shelters. Men muttered beneath their breath and even the children, who watched homing pigeons circling overhead, said it couldn't be so." The reporter interviewed pool parlor and candy store owner Tony Liacabuco, who strongly resented being called a squatter, as news reports routinely did at this point. "Squatters never pay rent and we did and we're willin' to," he said. Parents of large families interviewed were doubtful about the possibility of finding a new place to live. "'Don't you see what it means to us, having to get out?' cried the mother [Cecelia Willis]. 'We don't want anything but to stay here. What landlord wants a family with 11 children?'" Other islanders interviewed expressed similar worries, and many were unsure what they would do when April 15 came.[367]

As it turned out, they would have a bit more time to plan. Jane Shaw approached Moses with a plea to allow the one hundred or so students at PS 120 to finish the school year. Moses agreed, but that was the last extension.[368] On June 26, they had to leave. Barren Island, described by the *Eagle* that day as "one of the most picturesque rural communities within Brooklyn," had come to an end.[369]

There were a few postscripts to this last chapter. The island was not actually owned in full by the city, as the White family still retained title to part of it. Four families moved to the White land, joining thirty-five families that already lived there, and by July 19, there were still six additional families that refused to leave the city-owned land, one being that of Tony Liacabuco, who pointed out that he had invested money in his small business, for which he was getting no compensation. These six families contended that they had the right to some money from the city.[370] Their argument was countered by

the city, which made an "intensive study" and concluded, essentially, that the islanders should have known this would happen and that they were due nothing from the city. It is not clear when the last few families left either the city-owned or the privately owned land, but they were certainly gone by 1941, when the navy took over the operation of Floyd Bennett Field.

Although there were many novel aspects of life on Barren Island during this last period, the essential characteristics of the island community remained consistent. Islanders fended for themselves while a new road and airport rose around them. When jobs left the island with the garbage factory's closure, many residents found new homes and moved on with their lives. The remaining islanders took advantage of the opportunities these changes offered, from learning about automobiles to sending toy parachutes up on rides to going to high school and jobs off the island. They also took advantage of Jane Shaw's influence in the granting of the eviction extension. There was never a time when the community disintegrated, even though that would have been unsurprising under all of its sudden new pressures. Barren Island's community ended as it began, with independent people who worked hard and took care of themselves and their families.

CONCLUSION

Many New Yorkers and tourists still visit the site of Barren Island today, but most have no idea of the history of the community that once blossomed on the ground they are stepping on. Enthusiasts of aviation history often visit Floyd Bennett Field, where the runways are still visible, though covered with weeds, and several buildings, including hangars, survive. Other visitors beachcomb on the opposite side of Flatbush Avenue, at Dead Horse Bay (also known as "Bottle Beach"), where seemingly infinite amounts of 1950s garbage have burst a landfill cap and are emerging slowly on the surface. Mixed among the shoes, stockings, rusty household fixtures and bottles of every shape, size and color—and alongside whelks, clamshells, seaweed and snails—are neatly sliced horse bones, reminders of the factory workers who for eight decades turned New York City's waste into useful products.

"They were hard-working people, and they made the best of their lives. They tried to become good citizens. They worked hard, and they earned their living by their hands and their minds." These are the words of William Maier, recalling the community in which he spent the first eighteen years of his life. There is nothing dramatic or unusual in this statement on the face of it. But the fact that Barren Islanders created a functioning, indeed in many ways flourishing, community, in spite of isolation and neglect, is worthy of note. Without benefit of most municipal services or institutions, and starting from scratch on an uninhabited scrap of marshland, the "offensive industries" workers and their families built a community where none had

existed within living memory. Their jobs were considered disgusting by outsiders, but these very same outsiders, simply by living in New York City, benefited incalculably from the work of Barren Islanders.

The people of Barren Island were in some ways a microcosm of the United States. New immigrants who were part of demographic waves of the time—at first from Ireland and Germany, later from Eastern Europe and Italy—as well as African Americans whose job prospects were limited by discrimination in education and employment, the islanders adjusted to a physical and social environment that would have been alien to just about all of them. Many did not share a language, yet they still managed to create a miniature society in which, by all accounts, people mostly got along with each other and took care of themselves. When it came time to socialize, Barren Islanders mainly interacted with others from their own background (just as did other new Americans in their Little Italys, Chinatowns and other ethnic enclaves). But at work and at times of crisis, they were able to collaborate smoothly and effectively, whether operating dangerous machinery or assembling an impromptu bucket brigade to fight a fire.

Horse bones can still be found on the beach at Dead Horse Bay, on the former site of Barren Island, among natural materials and garbage from a 1950s landfill. *Photographed by the author in 2018. Author's collection.*

Outsiders consistently saw Barren Islanders as pathetic, practically helpless foreigners, people who didn't even know how to cook or raise children and whose uncivilized nature made them immune to smells that would fell more refined examples of humanity. These views helped rationalize the authorities' neglect of the islanders' need for basic services that were provided to other New Yorkers at the time—fire protection, running water and paved roads. It was also easy to dismiss the needs of Barren Islanders, as they were physically located so far away from the rest of the city. The island was often literally inaccessible by any means of transportation, and the islanders tended not to travel frequently to the mainland. It was difficult both for outside authorities to visit and check on the island and for residents to travel elsewhere to demand attention.

By studying Barren Island, we can learn more not only about one tiny, unusual community, but also about a number of larger topics that have resonance both historically and today. Urban sanitation workers' lives are little studied, even though without these workers, the cities in which more and more of the global population lives could not function. Innovative means of waste management are a hot topic in the twenty-first century, but the workers who actually perform the labor of tasks like recycling are often left out of the planning conversation. Another benefit to studying Barren Island is its place on the edges of New York City. New York has often been treated as synonymous with the financial, industrial and cultural highlights of Manhattan, while vastly less attention is paid to its humbler neighborhoods, including those that have a close connection to the natural world, like Barren Island. Yet these places are just as integral to the city as Manhattan's landmarks and institutions.

Under the fragile circumstances in which Barren Island existed, it would not have been surprising if the community had fallen apart, unable to sustain itself under the pressure of a mixture of cultures, difficult work and neglect of basic needs. Instead, with a pragmatic combination of personal responsibility, enthusiastic acceptance of the few services offered and creative and flexible solutions to everyday problems, Barren Islanders were able to build a thriving community on New York City's garbage.

NOTES

Introduction

1. "Hunt Wild Hogs on Barren Island," *New York Times*, March 17, 1909, 18. All quotes on this and the following page are from this article.
2. Burrows and Wallace, *Gotham*, 786.
3. "Hunt Wild Hogs on Barren Island," *New York Times*, March 17, 1909, 18.
4. "Barren Island Port of Missing Things," *Brooklyn Daily Eagle*, November 10, 1912, 14.
5. Murphy, "Life Near a Landfill."
6. Cody and Auwaerter, *Cultural Landscape Report*.
7. Ancestry.com, *1910 United States Federal Census*.
8. "Dumping Garbage at Sea," *Brooklyn Daily Eagle*, May 23, 1906, 4, to cite one of many similar examples.
9. "Millions of Menhaden," *Brooklyn Daily Eagle*, November 11, 1894, 8.
10. "The Ice Harvest," *New York Times*, January 13, 1873, 8; "The Great Ice Harvest," *Sun*, January 13, 1873, 3; "The Ice Crop," *New York Times*, February 15, 1873, 8.
11. "2018 Fiscal Year-to-Date Report," New York City Department of Sanitation.
12. Pellow, *Garbage Wars*, 122.
13. New York State Board of Health, *In the Matter of the Investigation*.
14. Black, *Jamaica Bay*.
15. John Milner Associates, *A Cultural Resources Inventory*; Wuebber and Morin, *Modified Phase IA Cultural Resources Inventory*; John Milner Associates, *Archeological Overview*; Cody and Auwaerter, *Cultural Landscape Report*.
16. Olsen, "What Do You Do With the Garbage?"

17. Black, *Jamaica Bay*, 81.

18. Johnson, "All the Dead Horses Next Door."

19. Zimring, *Cash for Your Trash*, 166.

20. Nagle, *Picking Up*, 23.

21. Ibid., 18.

22. Ibid., 198.

23. Burnstein, *Next to Godliness*, 20.

24. Ibid., 29.

Chapter 1

25. Black, *Jamaica Bay*, 8–9.

26. Ibid., 20.

27. Cody and Auwaerter, *Cultural Landscape Report*, 7.

28. Black, *Jamaica Bay*, 14.

29. Cody and Auwaerter, *Cultural Landscape Report*, 16.

30. DuBois, "History of the Town of Flatlands," 77.

31. "Bay Sucks in Warehouse Within Just 13 Minutes," *Brooklyn Daily Eagle*, November 26, 1905, 1.

32. "Barren Island Still Going," *New York Times*, November 27, 1905, 1.

33. "Building Cut in Two to Save It from the Sea," *New York Times*, November 28, 1905, 18.

34. "Bay Sucks in Warehouse."

35. "Barren Island Sinking Puzzles the Engineers," *Brooklyn Daily Eagle*, December 3, 1905, 7.

36. "Building Cut in Two to Save It from the Sea."

37. Wuebber and Morin, *Modified Phase IA Cultural Resources Inventory*, 8.

38. DuBois, "History of the Town of Flatlands," 77.

39. "Overcome by Sandstorm, Man Drops Unconscious on Airport at Barren Island," *Brooklyn Daily Eagle*, January 18, 1929, 1.

40. DuBois, "History of the Town of Flatlands," 77.

41. "Barren Island and Its People," *Brooklyn Daily Eagle*, May 31, 1908, 23.

42. "150 Barren Island Tots, Who Never Saw Tree, to Visit Fairy Mainland," *Brooklyn Daily Eagle*, April 11, 1921, 10.

43. I am drawing this and all subsequent information about William Maier from William Maier (former Barren Island resident), interview by National Park ranger John Lincoln Hallowell, 2012, transcript.

44. Cody and Auwaerter, *Cultural Landscape Report*, 22.

45. Ibid., 18.

46. "Two of Judge Steers' Cases Postponed by Fog—Daughter Against Father" *Brooklyn Daily Eagle*, December 8, 1897, 5; "Disabled Steamers on Canarsie Bay Cause Another Adjournment of a Flatbush Police Court Case," *Brooklyn Daily Eagle*, December 15, 1897, 4.

47. "Jamaica Bay Frozen Over," *Brooklyn Daily Eagle*, February 2, 1899, 7.

48. "Frozen in His Seat," *Brooklyn Daily Eagle*, February 10, 1899, 7.

49. "Canarsie Still Buried—Jamaica Bay Frozen Over to Barren Island," *Brooklyn Daily Eagle*, February 15, 1899, 3.

50. "Oystermen Hard Fixed," *Brooklyn Daily Eagle*, February 19, 1904, 3.

51. "Frozen Girl Identified," *Brooklyn Daily Eagle*, February 13, 1912, 3; "Find Body Under Ice," *New York Times*, February 13, 1912, 1.

52. John Milner Associates, *Archeological Overview and Assessment*, 4.

53. Black, *Jamaica Bay*, 6, 8–9.

54. DuBois, "History of the Town of Flatlands," 77–78.

55. Ibid., 78.

56. Ibid.; John Milner Associates, *Cultural Resources Inventory*, 8.

57. Cody and Auwaerter, *Cultural Landscape Report*, 7.

58. Black, *Jamaica Bay*, 14.

59. "Had N.Y. Pirates Arrested," *New York Times*, February 25, 1907, 9.

60. *Flatlands*, 35.

61. "Barren Island, the Place of Awful Stenches," *Brooklyn Daily Eagle*, August 20, 1877, 2.

62. Black, *Jamaica Bay*, 26.

63. Ibid., 27.

64. "Must Barren Island Go?" *Sun*, October 26, 1890, 14.

65. Black, *Jamaica Bay*, 32.

66. Ibid., 33.

67. "Women of Barren Island," *New-York Tribune*, June 23, 1899, 5.

68. "'Horse Factories' Busy Over at Barren Island," *Brooklyn Daily Eagle*, December 11, 1904, 17.

69. "Barren Island and Its People."

70. Ancestry.com, *1910 United States Federal Census*.

71. Ancestry.com, *1930 United States Federal Census*; Ancestry.com, *1940 United States Federal Census*.

72. "'Horse Factories' Busy Over at Barren Island."

73. "Barren Island and Its People."

74. For example, "Riot on Barren Island," *Brooklyn Daily Eagle*, October 16, 1871, 3.

Chapter 2

75. Olsen, "What Do You Do With the Garbage?"

76. "A Disgusting Nuisance," *New York Times*, August 26, 1877, 12.

77. "Brooklyn," *New York Times*, March 6, 1880, 8.

78. New York State Board of Health, *In the Matter of the Investigation*.

79. Ibid.

80. Ibid.

81. "The End of Barren Island," *New York World*, April 28, 1899, 5.

82. Kiechle, *Smell Detectives*, 232.

83. Ibid., 234.

84. "Excited. Residents of Flatlands Protest against the Barren Island Nuisance," *Brooklyn Daily Eagle*, February 1, 1881, 3.

85. "To Tackle Barren Island," *Evening World*, August 18, 1888, 3.

86. New York State Board of Health, *In the Matter of the Investigation*.

87. Mac M., letter to the editor, *Brooklyn Daily Eagle*, July 19, 1897.

88. R. Boocock, letter to the editor, *Brooklyn Daily Eagle*, December 21, 1898.

89. New York State Board of Health, *In the Matter of the Investigation*.

90. Mac M., letter to the editor.

91. "Barren Island Nuisance," *Sun*, August 14, 1897, 8.

92. "Odoriferous. Can a Man Be Ejected from a Railroad Train Because He Smells?," *Brooklyn Daily Eagle*, June 11, 1879, 4.

93. New York State Board of Health, *In the Matter of Barren Island*.

94. Ibid.

95. New York State Board of Health, *In the Matter of the Investigation*.

96. "To Tackle Barren Island," *Evening World*, August 18, 1888, 3.

97. "Triumph of Utilization," *Brooklyn Daily Eagle*, August 13, 1899, 15.

98. "Barren Island's People," *Sun*, October 1, 1899, 26.

99. "Ibid.

100. "Good Work of School on Barren Island," *Brooklyn Daily Eagle*, August 18, 1901, 7.

101. "Barren Islanders Happy Despite Big Handicap," *Sun*, August 15, 1915, 46.

102. "Says Barren Island Is Forgotten by God," *Brooklyn Daily Eagle*, March 8, 1915, 3.

103. Mayper, "Americanizing Immigrant Homes" (all quotes beginning with "In the interior of the houses").

104. "Good Work of School on Barren Island."

105. "Barren Islanders Happy Despite Big Handicap."

106. Ibid.

107. "Barren Island and Its People," *Brooklyn Daily Eagle*, May 31, 1908, 23.

108. "Barren Islanders Happy Despite Big Handicap."

109. "Good Work of School on Barren Island."

110. Daniel T. Edwards, letter to the editor, *Brooklyn Daily Eagle*, August 25, 1901.

111. "Woman Jailer Held Prisoner From Mob," *Brooklyn Daily Eagle*, October 23, 1912, 18; "Biffs and Whiffs Greet Two Sleuths on Barren Island," *Evening World*, October 23, 1912.

112. "Barren Island Not 'Abode of Terrors,'" *Brooklyn Daily Eagle*, November 3, 1912, 26.

113. "Barren Island Grieves Over Mentor's Death," *Brooklyn Daily Eagle*, April 20, 1932, 10.

114. "Miss Jane Shaw, Educator, Dies," *Brooklyn Daily Eagle*, September 5, 1939, 11.

115. "Finds Barren Island Richest Spot on Earth," *Brooklyn Daily Eagle*, June 22, 1930, 6.

116. I am drawing this and all subsequent information about Josephine Smizaski from Josephine Smizaski (former Barren Island resident), interview by Phyllis Smizaski, 2002, transcript.

117. "Barren Island Port of Missing Things," *Brooklyn Eagle*, November 10, 1912, 14.

Chapter 3

118. Maier, interview by National Park ranger John Lincoln Hallowell, 2012, transcript; Smizaski, interview by Phyllis Smizaski, 2002, transcript.

119. "Treasure Island at Our Doors; Day With Children of the Dumps," *Brooklyn Daily Eagle*, August 27, 1916, 60.

120. DuBois, "History of the Town of Flatlands," 77.

121. Olsen, "What Do You Do With the Garbage?"

122. "Triumph of Utilization," *Brooklyn Daily Eagle*, August 13, 1899, 15.

123. "The Coming Ice Harvest," *New York Times*, January 21, 1882, 2.

124. "Barren Island," *Brooklyn Daily Eagle*, April 24, 1856, 2.

125. Ibid.

126. "Utilizing Dead Animals," *Brooklyn Daily Eagle*, October 9, 1887, 11.

127. "The Utilization of New York City Garbage," *Scientific American*, August 14, 1897, 102.

128. "Barren Island, the Place of Awful Stenches," *Brooklyn Daily Eagle*, August 20, 1877, 2.

129. Black, *Jamaica Bay*, 26.

130. "Wanted—Six colored men to work at fish factory on Barren Island," *Sun*, May 31, 1880, 4.

131. "To Tackle Barren Island," *Evening World*, August 18, 1888, 3.

132. "Millions of Menhaden," *Brooklyn Daily Eagle*, November 11, 1894, 8.

133. Ancestry.com, *1910 United States Federal Census*.

134. "Teachers in Trouble on Barren Island," *Brooklyn Daily Eagle*, January 14, 1912, 59.

135. "Barren Island Port of Missing Things."

136. "Strike on Barren Island," *Brooklyn Daily Eagle*, June 27, 1899, 6.

137. "Whew! Barren Island Garbage Men Strike," *Sun*, April 12, 1913, 14.

138. "Explosion on Barren Island," *Sun*, April 3, 1885, 1.

139. "Injured By a Boiler Explosion," *New York Times*, April 3, 1885, 2.

140. "Scalded at Barren Island," *Brooklyn Daily Eagle*, December 28, 1897, 4.

141. "Harbor Police Heroes at Big Explosion," *Brooklyn Daily Eagle*, May 1, 1910, 1.

142. "Dillman's Horrible Death," *Evening World*, September 24, 1892, 3.

143. "His Arm Torn Off," *Brooklyn Daily Eagle*, December 13, 1896, 4.

144. "Man Ground to Pieces in Barren Island Plant," *Brooklyn Daily Eagle*, January 10, 1910, 3.

145. "Death May Follow Fall," *Brooklyn Daily Eagle*, April 7, 1910, 11.

146. "Breeze Tempered the Heat," *New York Times*, June 23, 1910, 1; "Dies of Injuries," *Brooklyn Daily Eagle*, February 20, 1911, 3; "Obituary: Marx Reipsch," *Brooklyn Daily Eagle*, October 16, 1911, 3; "A Roundabout Route; Corpse Taken From Barren Island to Canarsie by Way of Manhattan," *Brooklyn Daily Eagle*, January 12, 1912, 22.

147. "With Beer and Red Flags, Barren Island Workingmen Defiantly Greet Their Employers," *Brooklyn Daily Eagle*, September 17, 1887, 1.

148. "Strike on Barren Island," *Brooklyn Daily Eagle*, June 27, 1899, 6.

149. "Strike at Barren Island," *Brooklyn Daily Eagle*, October 18, 1899, 2.

150. "Whew! Barren Island Garbage Men Strike."

151. "Barren Island Is Out on a Strike," *New York Times*, April 12, 1913, 8.

152. "Whew! Barren Island Garbage Men Strike"; "Man Is Shot in Riot on Barren Island," *New York Times*, May 18, 1913, 2.

153. "Police in Battle with 300 Polacks," *Brooklyn Daily Eagle*, May 17, 1913, 2.

154. Ibid.

155. "Man Is Shot in Riot on Barren Island."

156. "Police in Battle with 300 Polacks."

157. Black, *Jamaica Bay*, 33.

158. "Barren Island's People."

159. "The Golden Age of Garbage," *New-York Tribune*, March 17, 1921, 10.

160. "Barren Island's People."

161. Daniel T. Edwards (letter to the editor), *Brooklyn Daily Eagle*, August 25, 1901.

162. "Finds Barren Island Richest Spot on Earth."

163. "Barren Island's People."

164. Mayper, "Americanizing Immigrant Homes."

165. "Barren Island's People."

166. Ibid.

167. "Barren Island Port of Missing Things."

168. "Treasure Island at Our Doors; Day With Children of the Dumps," *Brooklyn Daily Eagle*, August 27, 1916, 60.

169. "Golden Age of Garbage."

Chapter 4

170. "First Auto Trip on Record to Barren Island," *Brooklyn Daily Eagle*, January 27, 1918, 39.

171. "Women of Barren Island," *New-York Tribune*, June 23, 1899, 5.

172. "Barren Island Nuisances," *Brooklyn Daily Eagle*, June 23, 1885, 2.

173. "Hudson River Frozen Over," *Evening World*, February 7, 1895, 2; "Trolley Roads Recovering," *Evening World*, February 9, 1895, 3.

174. "The Life-Saver of Barren Island," *New York Times*, August 13, 1882, 12.

175. "Fought with Pirates," *Sun*, January 27, 1897, 3.

176. "Jamaica Bay Icebound," *Brooklyn Daily Eagle*, February 6, 1905, 18.

177. "Frozen Girl Identified," *Brooklyn Daily Eagle*, February 13, 1912, 3; "Find Body Under Ice," *New York Times*, February 13, 1912, 1.

178. "Dog, Barking for Hours, Saves Man Trapped in Quicksands," *Brooklyn Daily Eagle*, November 7, 1927, 3.

179. "Youth Sinking in Mud Saved After 2 Hours," *New York Times*, November 23, 1930, 37.

180. "How Children Are Taught in Public Kindergartens," *Brooklyn Daily Eagle*, August 18, 1901, 7; Daniel T. Edwards (letter to the editor), *Brooklyn Daily Eagle*, August 25, 1901.

181. Johnson, "All the Dead Horses Next Door."

182. Ibid.

183. "Barren Island Outing," *Brooklyn Daily Eagle*, August 17, 1899, 5.

184. "Children Enjoy Outing," *Brooklyn Daily Eagle*, September 4, 1902, 18.

185. "150 Barren Island Tots, Who Never Saw Tree, to Visit Fairy Mainland," *Brooklyn Daily Eagle*, April 11, 1921, 10; "Barren Island Kiddies Get Treat," *Evening World*, April 22, 1921, 32.

186. "Barren Island Children See Circus and Warmly Approve," *Brooklyn Daily Eagle*, May 6, 1921, 2.

187. "Women of Barren Island," *New-York Tribune*, June 23, 1899, 5.

188. "Barren Island Outing."

189. "Catholic Church on Barren Island," *New-York Tribune*, June 11, 1900, 8.

190. "A New M.E. Church," *Brooklyn Daily Eagle*, July 12, 1900, 5.

191. "Barren Island Chapel," *Brooklyn Daily Eagle*, July 13, 1900, 3.

192. "Barren Island Toilers Hear Their Native Tongue," *Brooklyn Daily Eagle*, May 11, 1908, 3.

193. "Barren Island and Its People," *Brooklyn Daily Eagle*, May 31, 1908, 23.

194. "Buys Barren Island Church," *Brooklyn Daily Eagle*, October 8, 1922, 40.

195. Sharp, *Priests and Parishes of the Diocese of Brooklyn*, 204.

196. Wilkinson, "Little Known Barren Island."

Chapter 5

197. "Laying the Groundwork: 1865–1945," New York City Fire Museum, accessed March 1, 2018, http://www.nycfiremuseum.org/history_laying_ground.cfm.

198. "Garbage Plant Burned; Sea-Dumping Likely," *Brooklyn Daily Eagle*, May 21, 1906, 3.

199. "Barren Island Fire," *Evening World*, March 21, 1892, 1.

200. "Fire on Barren Island," *Sun*, March 22, 1892, 6.

201. "A Barren Island Factory Burned," *New York Times*, March 22, 1892, 9.

202. "Little Boy Burned to Death," *Brooklyn Daily Eagle*, March 21, 1906, 5.

203. "Garbage Plant Burned."

204. "Barren Island Burns," *New-York Tribune*, May 21, 1906, 1.

205. "Garbage Plant Burned."

206. "$1,500,000 Fire Loss on Barren Island," *New York Times*, May 21, 1906, 1.

207. "Barren Island Burns."

208. "$1,500,000 Fire Loss on Barren Island."

209. For example, "Public Park in Barren Island Advocated," *Brooklyn Daily Eagle*, March 12, 1906, 21; "Now Reform Barren Island," *Brooklyn Daily Eagle*, May 21, 1906, 4.

210. "Sanitary Plant Burns," *New York Times*, May 13, 1907, 6.

211. "Barren Island Plant Damaged $40,000 By Fire," *Evening World*, March 10, 1908, 4.

212. "Barren Island Ablaze," *Sun*, March 25, 1911, 1.

213. "$200,000 Fire Loss at Barren Island," *Brooklyn Daily Eagle*, May 19, 1916, 3.

214. "Fire on Barren Island," *New York Times*, August 1, 1916, 7.

215. "Barren Island Fire Destroys Big Plant With $1,000,000 Loss," *Brooklyn Daily Eagle*, August 28, 1917, 1.

216. "Ten Buildings Burn on Barren Island," *Sun*, August 29, 1917, 6.

217. "Barren Island Fire Menaces Residents; Big Building Razed," *Brooklyn Daily Eagle*, June 21, 1921, 1.

218. "Unprotected Homes on Barren Island Are Razed By Fire," *Brooklyn Daily Eagle*, March 22, 1922, 22.

219. Ibid.; "Bucket Brigade Fights Fire in Barren Island," *Evening World*, June 17, 1922, 5; "Fire on Barren Island," *New York Times*, June 18, 1922, 3.

220. "Barren Island Fire Company Needs Hose," *Brooklyn Daily Eagle*, December 31, 1922, 33.

221. "Barren Island Has Lively 2 A.M. Fire," *Brooklyn Daily Eagle*, October 14, 1924, 17.

222. Mary O'Flaherty, "Millions for Airport, Nothing for Barren Isle, Cries Teacher," *Brooklyn Daily Eagle*, September 8, 1931, 5.

223. "Tammany Disregarded It," *New-York Tribune*, September 27, 1901, 6.

224. "Big Supply of Water Tapped at 800 Ft. Depth," *Brooklyn Daily Eagle*, March 26, 1908, 1.

225. "Teachers Forced to Drink Rain Water," *Brooklyn Daily Eagle*, June 4, 1909, 20.

226. "History of New York City's Water Supply System," New York City Department of Environmental Protection, accessed March 1, 2018, http://www.nyc.gov/html/dep/html/drinking_water/history.shtml.

227. "For driving well at Public School 120, Barren Island, Borough of Brooklyn," *Brooklyn Daily Eagle*, November 30, 1909, 16.

228. "Barren Island Port of Missing Things."

229. "Barren Islanders Happy Despite Big Handicap."

230. "Finds Barren Island Richest Spot on Earth."

231. O'Flaherty, "Millions for Airport."
232. Jackson, ed., *Encyclopedia of New York City*, 745.
233. "Barren Islanders Happy Despite Big Handicap."
234. "Want a Footbridge," *Brooklyn Daily Eagle*, November 16, 1897, 4.
235. "Barren Island Port of Missing Things."
236. "Finds Barren Island Richest Spot on Earth."
237. O'Flaherty, "Millions for Airport."
238. Ibid.

Chapter 6

239. "A Barren Island Quarrel," *Brooklyn Daily Eagle*, November 15, 1883, 4.
240. "A Probable Murder," *Brooklyn Daily Eagle*, January 23, 1884, 4.
241. "A Barren Island Tragedy," *Brooklyn Daily Eagle*, April 3, 1885, 4; "The Barren Island Tragedy," *Brooklyn Daily Eagle*, April 4, 1885, 8; "City and Suburban News," *New York Times*, April 4, 1885, 3; "Fatally Beaten," *Sun*, April 4, 1885, 1.
242. "The Death of Michael Cooley," *Brooklyn Daily Eagle*, April 16, 1885, 1
243. "The Barren Island Fight," *Brooklyn Daily Eagle*, June 3, 1885, 6.
244. "Mrs. Doll's Weight Told," *Brooklyn Daily Eagle*, May 28, 1902, 3.
245. "Acid or Water, It Burned," *Brooklyn Daily Eagle*, November 22, 1910, 3.
246. "Lost His $235 Savings While He Slept," *New York Times*, August 13, 1909, 7.
247. "Barren Islanders Fight," *Brooklyn Daily Eagle*, April 27, 1911, 1.
248. "Finds Barren Island Richest Spot on Earth."
249. "A Barren Island Affray," *Brooklyn Daily Eagle*, September 29, 1902, 20.
250. "Officer Had Grit," *New-York Tribune*, March 8, 1910, 4; "Negro Accused of Murder," *Brooklyn Daily Eagle*, March 8, 1910, 1.
251. "Riot on Barren Island," *Brooklyn Daily Eagle*, October 16, 1871, 3; "Shoots Pair, Stabs Man, Flees in Boat," October 8, 1917, 2.
252. "German Kills Opponent in Argument on Peace," *New-York Tribune*, November 4, 1918, 16.
253. "Barren Island Storm-Bound," *Brooklyn Daily Eagle*, January 15, 1912, 18.
254. "'A Day After the Fair,'" *Brooklyn Daily Eagle*, May 1, 1873, 2.
255. "Barren Island Rascality," *Brooklyn Daily Eagle*, February 12, 1874, 4.
256. "12 Years Excise-Free, Barren Island Shocked," *Brooklyn Daily Eagle*, March 31, 1909, 20.
257. "Berger Hadn't Paid Tax," *Brooklyn Daily Eagle*, May 18, 1909, 4.

258. "Whisky Salesman Fined," *Brooklyn Daily Eagle*, June 10, 1909, 15.

259. "Grand Jury to Quiz 5 in Rum Seizure," *Brooklyn Daily Eagle*, September 22, 1933, 9.

260. "He Bought Stolen Goods," *Brooklyn Daily Eagle*, October 31, 1905, 3.

261. "Had 970 Pieces of Silver," *New York Times*, October 31, 1905, 2.

262. "Stolen Silverware Found," *Brooklyn Daily Eagle*, January 15, 1911, 8.

263. "Silver at Barren Island," *Brooklyn Daily Eagle*, January 30, 1911, 3.

264. "Berlinger in Trouble," *Brooklyn Daily Eagle*, August 12, 1898, 12.

265. "Nobody Poisoned Yet," *Brooklyn Daily Eagle*, January 27, 1902, 1.

266. "Hunt Jealous Suitor in Death of Lured Man," *Brooklyn Daily Eagle*, September 25, 1930, 19; "Taxi Driver Held Without Bail in Jealousy Killing," *Brooklyn Daily Eagle*, September 26, 1930, 20; "Body of Man Wanted for Murder Is Found," *Brooklyn Daily Eagle*, October 1, 1930, 8; "Driver Held for Murder," *Brooklyn Daily Eagle*, October 2, 1930, 21.

267. "Two Game Guardians Seized in Duck Killing," *Brooklyn Daily Eagle*, May 6, 1930, 2.

268. "2 Jailed for 'Bootlegging' Uncertified Water Clams," *Brooklyn Daily Eagle*, August 11, 1931, 5.

269. "Goats Found Eating Big Marijuana Crop Near Bennett Field," *Brooklyn Daily Eagle*, August 19, 1936, 2; "Five Acres of Marijuana Uprooted by Police; Barren Island Goats Were Thriving on It," *New York Times*, August 19, 1936, 16.

270. "Police for Barren Island," *Brooklyn Daily Eagle*, April 17, 1897, 16.

271. "Canarsie Notes," *Brooklyn Daily Eagle*, June 21, 1897, 4.

272. "Barren Island's People."

273. "'Horse Factories' Busy Over at Barren Island."

274. "Barren Island Cop Holds Post, Beats Dan Cupid," *Evening World*, April 3, 1912, 3.

275. "Baffled the Police Force," *Sun*, April 15, 1912, 4.

276. "Held Up By Women, He Says," *Brooklyn Daily Eagle*, October 22, 1912, 3; "Took a Bankroll to Barren Island Biff! Whiff! Biff!" *Evening World*, October 22, 1912, 18; "Woman Jailer Held Prisoner From Mob," *Brooklyn Daily Eagle*, October 23, 1912, 18.

277. "Barren Island Not 'Abode of Terrors.'"

Chapter 7

278. Skip Rohde, e-mail message to author, January 1, 2019.

279. "Lady," *New Yorker*, August 1, 1931, https://www.newyorker.com/magazine/1931/08/01/lady.

280. "120 Years of American Education: A Statistical Portrait," U.S. Department of Education Office of Educational Research and Improvement, accessed March 3, 2018, https://nces.ed.gov/pubs93/93442.pdf.

281. For example, "School Attendance Record Improves," *Brooklyn Daily Eagle*, December 23, 1926, 26; "Barren Island School Again Leads the City," *Brooklyn Daily Eagle*, April 30, 1927, 10; "Attendance Records in Brooklyn Schools," *Brooklyn Daily Eagle*, December 28, 1927, 14.

282. DuBois, "History of the Town of Flatlands," 79.

283. "Flatlands School Teachers Now on the Anxious Seat," *Brooklyn Daily Eagle*, January 10, 1896, 7.

284. "Must Barren Island Go?" *Sun*, October 26, 1890, 14.

285. "Flatlands School Teachers Now on the Anxious Seat."

286. "Growth of the Schools," *New-York Tribune*, April 18, 1896, 15.

287. "Next Year's School Moneys," *Brooklyn Daily Eagle*, April 30, 1897, 16.

288. "Barren Island's School," *Brooklyn Daily Eagle*, June 18, 1897, 5.

289. "Obnoxious Rule to Go," *Brooklyn Daily Eagle*, July 7, 1897, 16.

290. All quotations on this page are from "To Clean Barren Island," *Brooklyn Daily Eagle*, September 17, 1897, 4.

291. New York City Board of Education Annual Report, 1898, 141.

292. "Is the Principal Insane?" *Brooklyn Daily Eagle*, February 25, 1899, 14.

293. "Barren Island's Public School," *Sun*, March 8, 1899, 4.

294. "Barren Island's School," *Sun*, March 12, 1899, 16.

295. Ibid.

296. "Women of Barren Island," *New-York Tribune*, June 23, 1899, 5.

297. Ancestry.com, *1900 United States Federal Census*.

298. New York City Board of Education Annual Report, 1900, 223–25.

299. "Barren Island School," *New-York Tribune*, February 21, 1900, 5.

300. "New Brooklyn Schools," *Brooklyn Daily Eagle*, August 3, 1900, 4.

301. "More Room in the Schools," *Brooklyn Daily Eagle*, September 7, 1900, 2.

302. "New School Buildings Will Seat 15,000 Pupils," *Brooklyn Daily Eagle*, November 18, 1900, 41.

303. "Barren Island," *Brooklyn Daily Eagle*, December 2, 1900, 42.

304. "How Children Are Taught in Public Kindergartens," *Brooklyn Daily Eagle*, August 18, 1901, 7.

305. Daniel T. Edwards (letter to the editor), *Brooklyn Daily Eagle*, August 25, 1901.

306. New York City Board of Education Annual Report, 1913, 417.

307. "Barren Island and Its People."

308. "To Save It From the Sea."

309. "Teachers in Trouble on Barren Island," *Brooklyn Daily Eagle*, January 14, 1912, 59.

310. "Barren Island Port of Missing Things."

311. "Teachers in Trouble on Barren Island."

312. "School Heads Visit Abroad; Red Letter Day at Barren Isle," *Brooklyn Daily Eagle*, March 13, 1918, 18.

313. "Brave Teachers to Receive Higher Pay," *Brooklyn Daily Eagle*, February 21, 1918, 8.

314. "Good Work of School on Barren Island."

315. New York City Board of Education Annual Reports, 1900–15.

316. "School Heads Visit Abroad; Red Letter Day at Barren Isle," *Brooklyn Daily Eagle*, March 13, 1918, 18.

317. "Missionary Found for Barren Island," *Brooklyn Daily Eagle*, November 10, 1918, 51.

318. Resnick, "What America Looked Like."

319. "Missionary Found for Barren Island."

320. "How Woman Got Aides for Santa," *Brooklyn Daily Eagle*, December 27, 1925, 77.

321. "Somers and Stern Clash Again Over Education Bills," *Brooklyn Daily Eagle*, March 15, 1923, 4.

322. "91 Reject Chance of School Position on Barren Island," *Brooklyn Daily Eagle*, December 10, 1931, 15.

323. "Barren Island School Again Leads the City."

324. "Attendance Records in Brooklyn Schools," *Brooklyn Daily Eagle*, December 28, 1927, 14.

325. "Finds Barren Island Richest Spot on Earth."

326. Ibid.

327. Ancestry.com, *1930 United States Federal Census*.

328. "Lady," *New Yorker*, August 1, 1931, https://www.newyorker.com/magazine/1931/08/01/lady.

329. "Barren Island Grieves Over Mentor's Death," *Brooklyn Daily Eagle*, April 20, 1932, 10.

330. "The Joy of Barren Island," *School*, February 17, 1921, 421.

331. "Barren Island Grieves Over Mentor's Death."

332. "Woman Inspires Barren Island Along Road to Better Things," *Brooklyn Times*, December 13, 1931, page number missing.

333. "Gray-Haired Teacher With Broken Hip Holds Regular Classes While Lying Abed," *Brooklyn Daily Eagle*, May 8, 1935, 3.

334. "Miss Jane Shaw Will Retire as Fairy God Mother, Barren Island," *Daily Messenger* (Canandaigua, NY), July 24, 1936, 8.

335. "Miss Jane Shaw, Educator, Dies," *Brooklyn Daily Eagle*, September 5, 1939, 11.

336. Johnson, "All the Dead Horses Next Door."

337. "Gray-Haired Teacher With Broken Hip Holds Regular Classes While Lying Abed."

338. O'Flaherty, "Millions for Airport."

Chapter 8

339. "First Auto Trip on Record to Barren Island," *Brooklyn Daily Eagle*, January 27, 1918, 39.

340. "Staten Is. Plant Is Able Now to Handle All City Garbage," *Brooklyn Daily Eagle*, November 20, 1918, 1.

341. "Manning Vacates the Garbage Stay; Appeal to Be Taken," *Brooklyn Daily Eagle*, November 21, 1918, 3.

342. "Win Mayor to Plan to Banish Garbage from Barren Island," *Brooklyn Daily Eagle*, February 6, 1919, 3.

343. "Barren Island Closed," *Brooklyn Daily Eagle*, February 16, 1919, 20.

344. "Win Mayor to Plan to Banish Garbage from Barren Island."

345. Ancestry.com, *1900 United States Federal Census*.

346. "Waterfront Refining & Mfg. Plant, Barren Island, N.Y.," *New-York Tribune*, February 22, 1920, 28.

347. "Flatbush Avenue Extension," *Brooklyn Daily Eagle*, June 14, 1907, 13.

348. "Flatbush Av. Extension Cost on City At Large," *Brooklyn Daily Eagle*, November 3, 1907, 61.

349. "Plan to Extend Flatbush Avenue to Barren Island," *Brooklyn Daily Eagle*, January 15, 1913, 23.

350. "Barren Island Sees Future Prosperity in Ferry and New Flatbush Avenue Extension," *Brooklyn Daily Eagle*, February 7, 1926, 69.

351. Ibid.

352. Cody and Auwaerter, *Cultural Landscape Report for Floyd Bennett Field*, 30.

353. "Plane Skims Brooklyn House, Then Crashes," *New York Times*, September 4, 1929, 1; "2 in Plane Plunge into Jamaica Bay," *New York Times*, November 2, 1929, 15.

354. "Airport Crowds Causing Traffic Jams on the Road," *Brooklyn Daily Eagle*, April 20, 1930, 58.

355. Leo A. Kieran, "Municipal Airport Is Ready," *New York Times*, May 17, 1931, 128.

356. "City Votes Airport on Barren Island," *New York Times*, February 3, 1928, 9.

357. "World's First Roof-Top Landing Field to Link Downtown Brooklyn With Barren Island Airport; To Start Work on Municipal Project in Spring," *Brooklyn Daily Eagle*, February 12, 1928, 46.

358. "Byrd Dedicates Bennett Air Field," *New York Times*, June 27, 1930, 30.

359. Kieran, "Municipal Airport Is Ready."

360. "Stack Bars Airport From High Rating," *Brooklyn Daily Eagle*, February 7, 1932, 13.

361. "Chamber Will See Airport Stack Fall," *Brooklyn Daily Eagle*, March 18, 1937, 17.

362. Cody and Auwaerter, *Cultural Landscape Report*, 5.

363. Olsen, "What Do You Do With the Garbage?"

364. "What Is This Mystery About Barren Island?" *Brooklyn Daily Eagle*, May 30, 1935, 4.

365. Joseph Mitchell, "Barren Island, Community Built on a Garbage Dump, Awaits Its Hardest Winter," *World-Telegram*, September 17, 1935, page number missing.

366. Gertrude Emerick, "Heartbreak Settles Over Barren Island," *Brooklyn Daily Eagle*, March 14, 1936, 3.

367. Ibid.

368. "Lady Jane Wins a Brief Stay For Her Barren Island School," *Brooklyn Daily Eagle*, April 15, 1936, 7.

369. "400 Residents Moving From Barren Island," *Brooklyn Daily Eagle*, June 26, 1936, 21.

370. "6 Families Still Fight Eviction At Barren Isle," *Brooklyn Daily Eagle*, July 19, 1936, 14.

BIBLIOGRAPHY

Ancestry.com. *1900 United States Federal Census* [database online]. Provo, UT: Ancestry.com Operations Inc., 2004.

———. *1910 United States Federal Census* [database online]. Lehi, UT: Ancestry.com Operations, 2006.

———. *1920 United States Federal Census* [database online]. Provo, UT: Ancestry.com Operations, 2010.

———. *1930 United States Federal Census* [database online]. Provo, UT: Ancestry.com Operations, 2002.

———. *1940 United States Federal Census* [database online]. Provo, UT: Ancestry.com Operations, 2012.

Black, Frederick R. *Jamaica Bay: A History*. Washington, DC: National Park Service, 1981. https://www.nps.gov.

Brooklyn Daily Eagle, 1856–1939.

Brooklyn Times, 1931.

Burnstein, Daniel Eli. *Next to Godliness: Confronting Dirt and Despair in Progressive Era New York City*. Urbana: University of Illinois Press, 2006.

Burrows, Edwin G., and Mike Wallace. *Gotham: A History of New York City to 1898*. New York: Oxford University Press, 1999.

Cody, Sarah K., and John Auwaerter. *Cultural Landscape Report for Floyd Bennett Field*. Boston: National Park Service, 2009. archive.org/details/culturallandscap09floyd.

Daily Messenger (Canandaigua, NY), 1936.

DuBois, Anson. "History of the Town of Flatlands." In *The Civil, Political, Professional and Ecclesiastical History and Commercial and Industrial Record of the County of Kings and the City of Brooklyn, N.Y. from 1683 to 1884*, edited by Henry R. Stiles, 64–79. New York: W.W. Munsell & Co., 1884.

The Evening World, 1888–1921.

Flatlands. Brooklyn, NY: *Brooklyn Daily Eagle*, 1946. (Pamphlet published as a supplement to the Sunday *Eagle*.)

"History of New York City's Water Supply System." New York City Department of Environmental Protection. Accessed March 1, 2018. http://www.nyc.gov/html/dep/html/drinking_water/history.shtml.

Jackson, Kenneth T., ed., *The Encyclopedia of New York City*, 2nd ed. New Haven, CT: Yale University Press, 2010.

Jindrich, Jason. "When the Urban Fringe Is Not Suburban." *Geographical Review* 100, no. 1 (January 2010): 35–55.

John Milner Associates. *A Cultural Resources Inventory of the Gateway National Recreation Area, New York and New Jersey*. Denver: National Park Service, 1978.

———. *Archeological Overview and Assessment: Gateway National Recreation Area*. Lowell, MA: National Park Service, 2011.

Johnson, Kirk. "All the Dead Horses Next Door; Bittersweet Memories of the City's Island of Garbage." *New York Times*, November 7, 2000. http://www.nytimes.com.

"The Joy of Barren Island," *School*, February 17, 1921.

Kiechle, Melanie A. *Smell Detectives: An Olfactory History of Nineteenth-Century Urban America*. Seattle: University of Washington Press, 2017.

"Lady." *New Yorker*. August 1, 1931. https://www.newyorker.com.

"Laying the Groundwork: 1865–1945." New York City Fire Museum. Accessed March 1, 2018. http://www.nycfiremuseum.org.

Lewis, Robert, ed. *Manufacturing Suburbs: Building Work and Home on the Metropolitan Fringe*. Philadelphia: Temple University Press, 2004.

Maier, William (former Barren Island resident). Interview by National Park Ranger John Lincoln Hallowell, 2012, transcript.

Mayper, Joseph. "Americanizing Immigrant Homes." *The Immigrants In America Review* 2, no. 2 (July 1916): 54–60. https://hdl.handle.net/2027/coo.31924011951252.

Murphy, Jarrett. "Life Near a Landfill: The Towns and People Who End Up with NYC Trash." *City Limits*, May 22, 2015. https://citylimits.org.

Nagle, Robin. *Picking Up: On the Streets and Behind the Trucks with the Sanitation Workers of New York City*. New York: Farrar, Straus and Giroux, 2013.

New York City Board of Education Annual Reports, 1898–1915. NYC Department of Records/Municipal Archives.

New York City Department of Sanitation. "2018 Fiscal Year-to-Date Report." https://www1.nyc.gov.

New York State Board of Health. *In the Matter of Barren Island.* Albany, NY, 1891.

———. *In the Matter of the Investigation of the New York State Board of Health into the Alleged Nuisance Existing at Barren Island.* Albany, NY, 1897.

New York Times, 1885–1936.

New-York Tribune, 1899–1921.

New York World, 1899.

Olsen, Kevin. "What Do You Do With the Garbage? New York City's Progressive Era Sanitary Reforms and Their Impact on the Waste Management Infrastructure in Jamaica Bay." *Long Island History Journal* 24, no. 2 (2015). https://lihj.cc.stonybrook.edu.

"120 Years of American Education: A Statistical Portrait." U.S. Department of Education Office of Educational Research and Improvement. Accessed March 3, 2018. https://nces.ed.gov/pubs93/93442.pdf.

Pellow, David Naguib. *Garbage Wars: The Struggle for Environmental Justice in Chicago.* Cambridge, MA: MIT Press, 2002.

Resnick, Brian. "What America Looked Like: Collecting Peach Pits for WWI Gas Masks." *Atlantic,* February 1, 2012. https://www.theatlantic.com.

Sharp, Reverend John K. *Priests and Parishes of the Diocese of Brooklyn 1820–1944.* Brooklyn, NY: Episcopus Brooklyniensis, 1944.

Smizaski, Josephine (former Barren Island resident). Interview by Phyllis Smizaski, 2002, transcript.

Sun, 1880–1915.

Wilkinson, Ed. "Little Known Barren Island Part of Diocesan History." *Tablet,* August 24, 1916. thetablet.org/little-known-barren-island-part-of-diocesan-history.

Wuebber, Ingrid, and Edward M. Morin. *Modified Phase IA Cultural Resources Inventory, Floyd Bennett Field, Jamaica Bay Unit, Gateway National Recreation Area.* Denver, CO: National Park Service, 2005.

Zimring, Carl. *Cash for Your Trash: Scrap Recycling in America.* New Brunswick, NJ: Rutgers University Press, 2005.

INDEX

ABOUT THE AUTHOR

 Miriam Sicherman is a public elementary school teacher in New York City. She is a graduate of Oberlin College, Bank Street College of Education and Brooklyn College, and she lives in Brooklyn with her daughter.